CHICAGO
architecture & design

Edited by Michelle Galindo
Co-edited and written by Carissa Kowalski and Tonia Kim
Concept by Martin Nicholas Kunz

contents

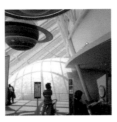

to see . culture & education

to see . public

contents

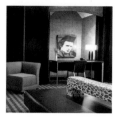

to stay . hotels

to go , eating, drinking, clubbing

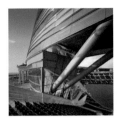

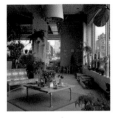

to go . wellness, beauty & sport

to shop . mall, retail, showrooms

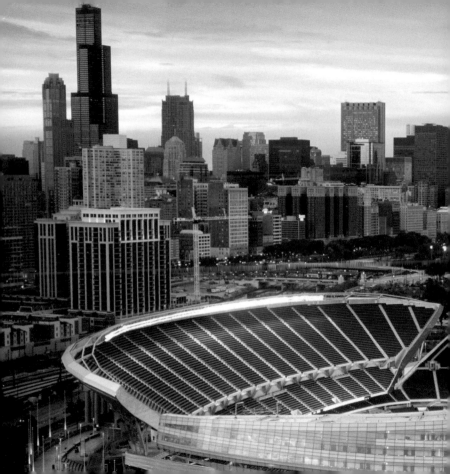

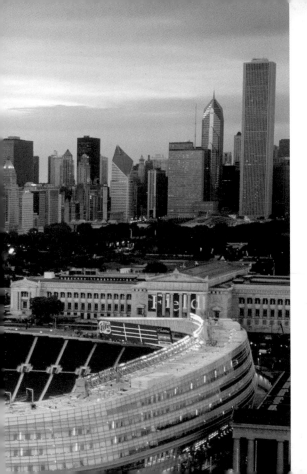

introduction

Cloud Gate Sculpture

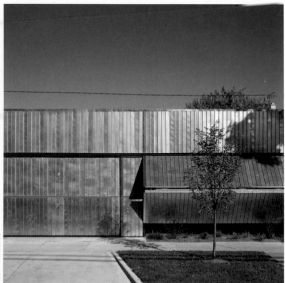
Doblin Residence

Architecturally, Chicago is the most important city in the USA. The reason is the "Great Fire of 1871", which destroyed most of the city and caused a new wave of urban planning. Architects like Frank Lloyd Wright, Daniel Burnham, Louis Sullivan and Mies van der Rohe influenced the city's new image. Mies van der Rohe's twin condominium towers on Lake Shore Drive made a lasting impression on modern, international architecture. It's noticeable recently that a new dynamic has taken hold of the architectural scene. Examples are the Jay Pritzker Pavilion, built by Frank O. Gehry, or the campus for the Illinois Institute of Technology by Rem Koolhaas, which are changing the city's look all over again.

Architekturhistorisch ist Chicago die bedeutendste Stadt der USA. Grund dafür ist das „Great Fire of 1871", das die Stadt weitgehend zerstörte und zur stadtplanerischen Neuausrichtung führte. Architekten wie Frank Lloyd Wright, Daniel Burnham, Louis Sullivan und Mies van der Rohe prägten das neue Stadtbild. Den nachhaltigsten Einfluss auf die moderne internationale Architektur üben Mies van der Rohes Doppel-Wohntürme am Lake Shore Drive aus. Gerade in den letzten Jahren gewinnt die Architekturszene aber wieder neue Dynamik. Beispiele sind der von Frank O. Gehry erbaute Jay Pritzker Pavilion oder der Campus des Illinois Institute of Technology von Rem Koolhaas, die das Gesicht der Stadt zum zweiten Mal verändern.

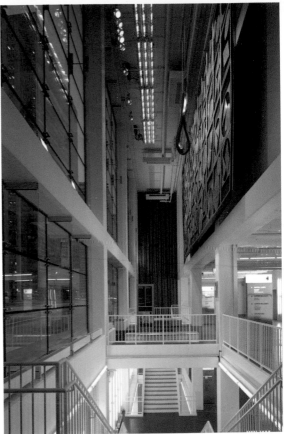

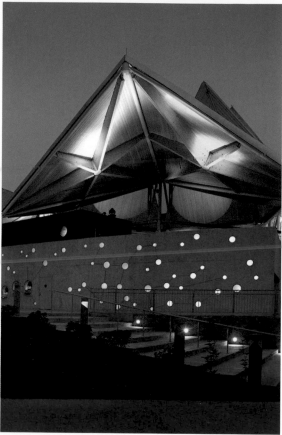

Du point de vue architectural, Chicago est la ville la plus importante des Etats-Unis. Le « Great Fire of 1871 » qui détruisit la ville en grande partie en est la cause, il contribua à une nouvelle orientation de l'aménagement urbain. Des architectes comme Frank Lloyd Wright, Daniel Burnham, Louis Sullivan et Mies van der Rohe marquèrent de leur empreinte la nouvelle physionomie de la ville. Les doubles tours d'habitation de Mies van der Rohe le long de Lake Shore Drive exercent toujours une influence sur l'architecture moderne internationale. Mais c'est précisément au cours de ces dernières années que la scène architecturale retrouve un nouveau dynamisme, avec par exemple le Jay Pritzker Pavilion construit par Frank O. Gehry ou le Campus de l'Illinois Institute of Technology de Rem Koolhaas, qui modifièrent une seconde fois l'apparence de la ville.

Chicago es la ciudad más relevante de los EE. UU. desde una perspectiva histórico arquitectónica. La razón la encontramos en el "Great Fire of 1871", un incendio que arrasó gran parte de la ciudad motivando su reordenación. Creaciones de arquitectos como Frank Lloyd Wright, Daniel Burnham, Louis Sullivan y Mies van der Rohe caracterizan la nueva imagen de la ciudad. Los dos rascacielos de viviendas de Mies van der Rohe, en Lake Shore Drive, simbolizan la influencia más persistente sobre la arquitectura internacional moderna. Ha sido precisamente a lo largo de los últimos años cuando la escena arquitectónica ha comenzado a ganar un nuevo dinamismo. Ejemplos de esta evolución los encontramos en el pabellón Jay Pritzker, diseñado por Frank O. Gehry, y en el campus del Illinois Institute of Technology, de Rem Koolhaas, construcciones que transforman por segunda vez la fisonomía de la ciudad.

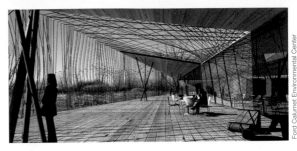

Ford Calumet Environmental Center

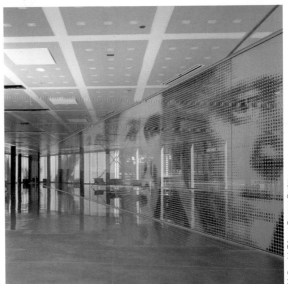

McCormick Tribune Campus Center

to see . living
office & industry
culture & education
public

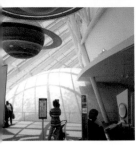
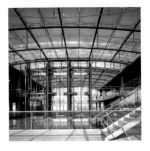

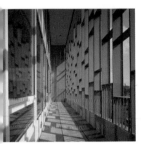
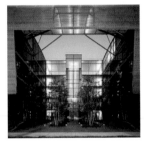
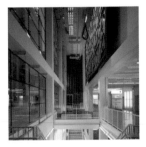
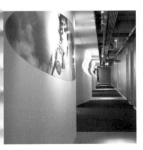
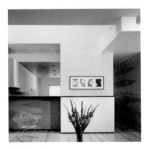
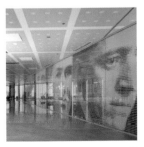

Thompson House

Brininstool + Lynch

1994
Bucktown

www.brininstool-lynch.com

The three-story Thompson House uses a diverse palette of materials to achieve an integrated volume of light-filled spaces. The austere, industrial aesthetic of the unfinished concrete block is juxtaposed with a variety of finish materials that give the home a warm interior.

Beim dreistöckigen Thompson House wurde eine reichhaltige Materialpalette verwendet, um ein ganzheitliches Gebäude mit lichtdurchfluteten Räumen zu erschaffen. Der strengen, industriellen Ästhetik des unbearbeiteten Betonblocks steht eine Vielzahl von Verputzmaterialien gegenüber, die dem Haus ein warmes Interieur verleihen.

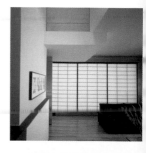

Pour la Thompson House de trois étages, une palette variée de matériaux a été utilisée de façon à créer un bâtiment d'ensemble avec des pièces baignées de lumière. Un grand nombre de matériaux en crépis font face à l'esthétique stricte et industrielle du bloc en béton non travaillé, conférant au bâtiment un intérieur chaleureux.

En la construcción de Thompson House, de tres alturas, se empleó una amplia gama de materiales para crear un edificio global con espacios inundados de luz. La severa estética industrial del bloque de hormigón sin tratar tiene su contrapunto en el gran número de revoques empleados en el interior, que dota a la casa de un ambiente cálido.

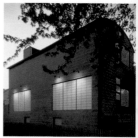

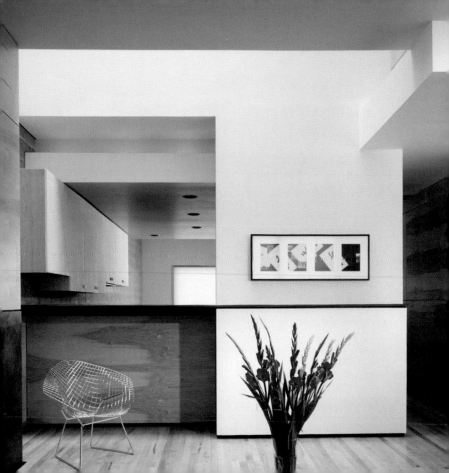

Pfanner House

Zoka Zola
Paula Price of Hutter Trankina Engineering (SE)

2002
1737 West Ohio Street
East Village

www.zokazola.com

Huge windows interrupt the building façade and convey a sense of openness to the street. Each room is clearly defined by changes in level and multiple orientations that give glimpses of other possibilities for experiencing the space.

Riesige Fenster durchbrechen die Fassade und vermitteln ein Gefühl der Offenheit zur Straße hin. Die einzelnen Räume sind klar definiert durch Unterschiede in der Ebene und verschiedene Ausrichtungen und lassen so ganz neue Möglichkeiten des Raumerlebnisses erahnen.

De très grandes fenêtres traversent la façade et confèrent un sentiment d'ouverture sur la rue. Les différentes pièces sont clairement définies à l'aide de variations de niveau et d'orientations variées et permettent une utilisation de l'espace entièrement nouvelle.

Enormes ventanas interrumpen la fachada y transmiten una sensación de abertura hacía la calle. Los diversos espacios están claramente definidos por las diferencias en los planos y en las orientaciones, insinuando así formas completamente nuevas de vivir el espacio.

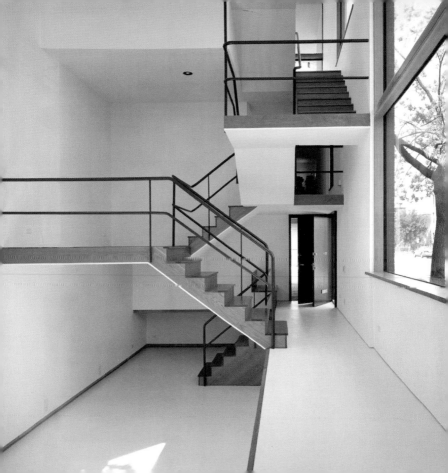

F10 House

EHDD Architecture
Klein and Hoffman (SE)

2003
1919 North Keeler Avenue
Hermosa

www.ehdd.com

Diminutive in size, the brick-red house nevertheless stands out among the neighboring buildings. The house represents the goal of reducing the negative environmental effects of the typical American house over its life cycle by a factor of ten. It is one of five winners in the "Green Homes for Chicago" competition.

Trotz seiner geringen Größe hebt sich das ziegelsteinrote Haus deutlich von den Nachbargebäuden ab. Sein Name steht für das Ziel, die negativen Umwelteinflüsse des typischen amerikanischen Hauses während seiner „Lebensdauer" um den Faktor zehn zu reduzieren. Es war einer der fünf Sieger des Wettbewerbs „Green Homes for Chicago".

Malgré sa taille peu élevée, l'édifice couleur rouge brique se distingue nettement des bâtiments voisins. Son nom met en valeur l'objectif visé : réduire au facteur dix les impacts négatifs sur l'environnement de la maison typique américaine au cours de sa « durée de vie ». La maison fut l'un des cinq vainqueurs du concours « Green Homes for Chicago » sponsorisé par la ville.

A pesar de su reducido tamaño, la casa de ladrillo rojo destaca claramente entre las viviendas vecinas. Su nombre se deriva de su objetivo: reducir diez veces los efectos negativos que la típica casa estadounidense ejerce sobre el medioambiente. La vivienda fue una de las cinco ganadoras del concurso "Green Homes for Chicago".

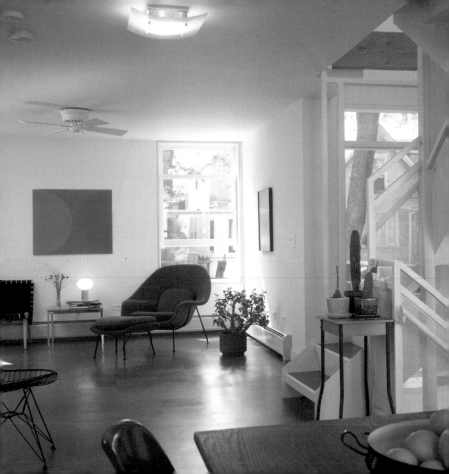

IIT Student Housing

Murphy/Jahn
Werner Sobek Ingenieure GmbH (SE)

2003
3303 South State Street
IIT

www.murphyjahn.com
www.ssv.iit.edu

State Street Village's three main volumes are oriented linearly to mirror the movement of the elevated train. This glass-and-steel structure is punctuated by entrance courtyards and walkways linking the main quadrangle to residential areas to the east. From the rooftop terraces residents enjoy a beautiful view of the city.

Die drei Hauptgebäude des State Street Village sind linear angeordnet, was die Bewegung der Hochbahn widerspiegeln soll. Diese Glas-Stahl-Konstruktion ist unterbrochen durch Eingangshöfe und Gehwege, die den viereckigen Hauptinnenhof mit den im Osten liegenden Wohnungen verbinden. Von den Dachterrassen aus genießen die Bewohner einen schönen Ausblick über die Stadt.

Les trois principaux bâtiments du State Street Village sont ordonnés de façon linéaire, reflétant le mouvement du métro aérien. Cette construction en acier et en verre est interrompue par des cours d'entrée et des trottoirs reliant la cour intérieure principale carrée aux appartements situées à l'est. Sur les terrasses des toits, les habitants ont une vue superbe de la ville.

La ordenación lineal de los tres edificios principales del State Street Village quiere reflejar el movimiento de un tren elevado. Los patios de entrada y los caminos interrumpen esta construcción de vidrio y acero, y unen el patio interior principal, cuadrado, con las viviendas, situadas al este. Desde las azoteas se puede disfrutar de una bonita vista sobre la ciudad.

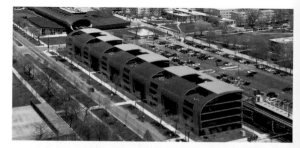

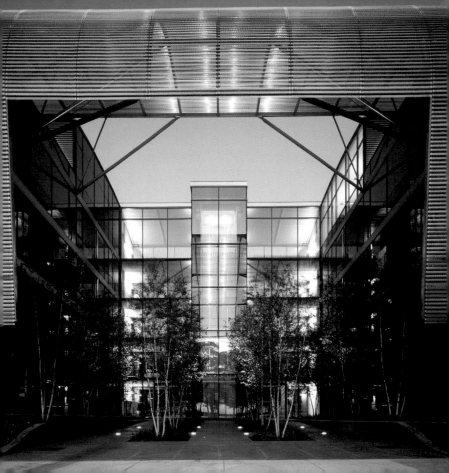

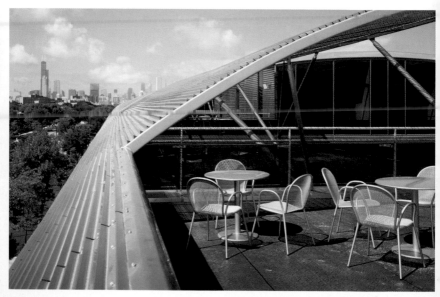

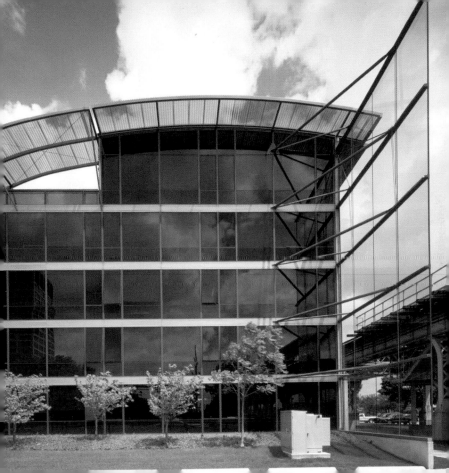

Tower House

Frederick Phillips and Associates
Thornton Tomasetti Engineers (SE)

2001
1306 North Cleveland Avenue
Old Town

www.frederickphillips.com

Frederick Phillips' Tower House is a modernist outpost on the edge of a rapidly changing neighborhood. A notable feature is the verticality and use of materials other than the traditional brick and block. The dark steel skeleton is offset by red window frames and corrugated metal cladding.

Das von Frederick Phillips errichtete Tower House ist ein modernistischer Außenposten am Rande einer sich rasant wandelnden Gegend. Bemerkenswert sind die Vertikalität sowie die Verwendung anderer Materialien als das traditionelle Ziegel-Blockmauerwerk. Dem dunklen Stahlskelett wirken rote Fensterrahmen sowie eine Wellblechummantelung entgegen.

La Tower House construite par Frederick Phillips est un édifice de banlieue moderniste situé à la limite d'une région caractérisée par une évolution rapide. Sa verticalité est remarquable, ainsi que l'utilisation d'autres matériaux comme les murs en tuiles traditionnels. Les châssis de fenêtres rouges et un revêtement en tôle ondulée font face au squelette sombre en acier.

La Tower House, de Frederick Phillips, es una destacada construcción modernista en los límites de un barrio en rápida transformación. Los elementos más característicos son la verticalidad y el uso de materiales diferentes a la tradicional mampostería de ladrillo. Los marcos rojos de las ventanas y la envoltura de plancha ondulada contrastan con el esqueleto de acero oscuro.

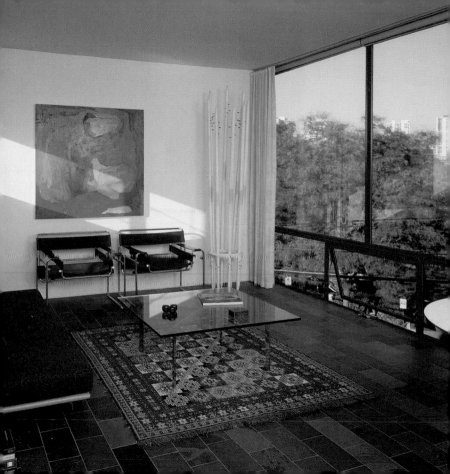

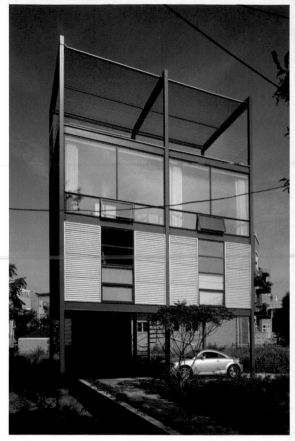

Pilsen Gateway

Landon Bone Baker Architects
Matsen Ford Design Associates (SE)

2004
1621 South Halsted Street
Pilsen

www.landonbonebaker.com

The two bold corner buildings are connected mid-block with a lower-scale horizontal element. The mixed-use, market rate development—part residential, part commercial—interacts with its surroundings with a mix of colors and materials that reflects the neighborhood's latino and artist communities.

Die beiden auffälligen Eckgebäude sind in der Mitte durch ein niedrigeres horizontales Element miteinander verbunden. Das den Marktbedingungen angepasste und für verschiedene Zwecke angelegte Gebäude – teils Wohn-, teils Geschäftshaus – interagiert durch einen Farb- und Materialmix mit den Latino- und Künstlergemeinden in seiner Umgebung.

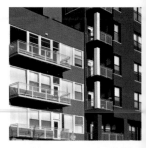

Les deux bâtiments en coin originaux sont reliés entre eux au milieu par un élément horizontal plus bas. Le bâtiment, adapté aux conditions du marché et conçu pour différents objectifs – en partie immeuble d'habitation, en partie immeuble de magasins – interagit à l'aide d'un mélange de couleurs et de matériaux avec les communautés latinos et artistiques environnantes.

Los dos llamativos edificios de esquina están unidos en el medio por un elemento horizontal bajo. La construcción, adaptada a la demanda y concebida para diferentes propósitos, parte residencial y parte comercial, interacciona con las comunidades de hispanos y artistas del barrio a través de la mezcla de colores y materiales.

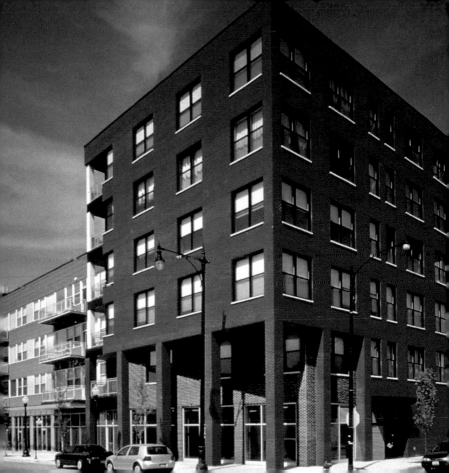

Markow Residence

Garofalo Architects
Thornton Tomasetti Engineers (SE)

1998
Prospect Heights

www.garofaloarchitects.com

This addition to the Markow Residence transformed the split-level suburban home into an interlocking series of spaces. The angular roof structure is a "vernacular mutation" of the typical suburban style; its topography reflects the complex circulation of the living spaces below.

Diese Ergänzung der Markow Residence verwandelte die in verschiedenen Ebenen angelegte Vorstadtresidenz in eine Reihe von ineinander greifenden Räumen. Die winkelige Dachstruktur ist eine „volkstümliche Mutation" des typischen Vorstadtbaustils, bei dem die Anordnung die Erschließung der darunter liegenden Wohnungen widerspiegelt.

Ce complément de la Markow Residence transforma la résidence de banlieue conçue sur plusieurs niveaux en une rangée de pièces s'emboîtant les unes dans les autres. La structure du toit tortueuse est une « mutation populaire » du style de construction typique de la banlieue où la disposition reflète l'aménagement des appartements situées en dessous.

Esta construcción añadida a la Markow Residence transformó la residencia suburbana estructurada en diferentes planos, en una serie de espacios entrelazados. La angulosa estructura de la cubierta, una "mutación popular" del típico estilo arquitectónico de la periferia, refleja la ordenación de las viviendas subyacentes.

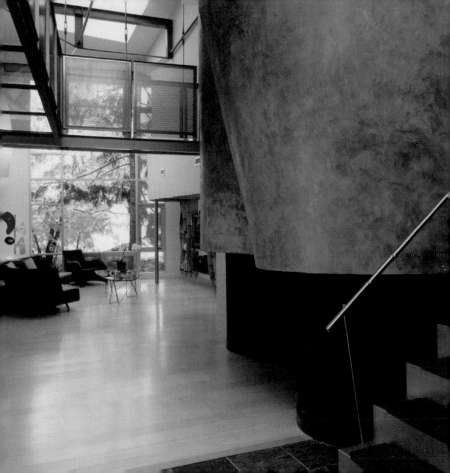

Doblin Residence

Valerio Dewalt Train Associates, Inc.
Robert Darvas Associates (SE)

2003
Ravenswood

www.vdtainc.com

The design for the Doblin Residence transformed the ruins of an old factory into a house with an industrial aesthetic. Galvanized scissors doors open to reveal a garage and entry court, beyond which the loft-style space expands in a structure of steel, glass, and original exposed brick walls.

Für die Doblin Residence wurden die Ruinen einer alten Fabrik zu einem Haus mit industrieller Ästhetik verwandelt. Verzinkte Flügeltüren geben den Blick frei auf einen Eingangshof mit Garage, hinter dem der wie ein Loft anmutende Raum in ein Gebilde aus Stahl, Glas und den freigelegten, ursprünglichen Backsteinmauern übergeht.

Pour la Doblin Residence, les ruines d'une ancienne usine ont été transformées en une maison à l'esthétique industrielle. Des portes battantes zinguées permettent de jeter un œil dans une cour d'entrée avec garage, derrière laquelle la pièce, rappelant un loft, se fond dans une construction d'acier, de verre et d'anciens murs en brique remis à jour.

En la construcción de la Doblin Residence, se transformaron las ruinas de una antigua fábrica en una casa de estética industrial. Las puertas batientes galvanizadas permiten la vista hacia el patio de la entrada con garaje, detrás del cual se extiende un espacio similar a un loft enmarcado en acero, cristal y los antiguos muros de ladrillo descubiertos.

Contemporaine
at 516 North Wells

Perkins+Will
C.E. Anderson & Associates (SE)

2004
516 North Wells Street
River North

www.perkinswill.com
www.cmkdev.com

The Contemporaine complex at 516 North Wells is considerably more modern than its mid-rise neighbors. The four-story retail and parking structure is surmounted by an eleven-story residential tower with stepped terraces and protruding cantilevered balconies.

Der Komplex des Contemporaine at 516 North Wells ist deutlich moderner als die angrenzenden mittelhohen Gebäude. Das vierstöckige Gebäude, in dem sich Verkaufs- und Parkflächen befinden, wird überragt von einem elfgeschossigen Wohnturm mit abgestuften Terrassen und hervorstehenden Freibalkons.

Le complexe du Contemporaine at 516 North Wells est nettement plus moderne que les bâtiments attenants de hauteur moyenne. L'immeuble de quatre étages, dans lequel se trouvent des zones de vente et des parcs, est surplombé par une tour d'habitation de onze étages avec des terrasses construites en gradins et des balcons en plein air faisant saillie.

El complejo del Contemporaine at 516 North Wells es claramente más moderno que los inmuebles colindantes de mediana altura. La construcción de cuatro pisos, donde se alojan superficies comerciales y aparcamientos, se ve superada en altura por el edificio de viviendas de once plantas con terrazas escalonadas y terrazas salientes.

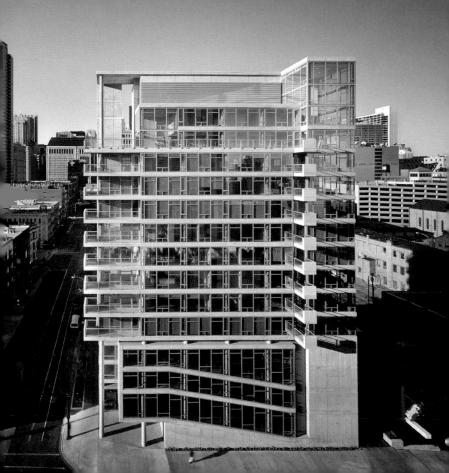

South Kenwood Residence

Vinci I Hamp Architects, Inc.
Nayyar & Nayyar International (SE)

2001
South Kenwood

www.vinci-hamp.com

The unornamented exterior, composed of brick and limestone, takes its cue from nearby landmark homes by Frank Lloyd Wright and Howard Van Doren Shaw. The bright interior is accentuated by tall windows and white walls to better showcase the owner's art collection.

Die schnörkellose Fassade aus Ziegel- und Kalkstein orientiert sich an nahe gelegenen charakteristischen Gebäuden von Frank Lloyd Wright und Howard Van Doren Shaw. Das durch hohe Fenster und weiße Wände akzentuierte helle Interieur bringt die Kunstsammlung des Besitzers perfekt zur Geltung.

La façade sans fioritures, en tuiles et en pierre calcaire, s'inspire des bâtiments voisins caractéristiques de Frank Lloyd Wright et de Howard Van Doren Shaw. L'intérieur, particulièrement clair grâce à de grandes fenêtres et aux murs blancs, met parfaitement en valeur la collection d'art du propriétaire.

La fachada de ladrillo y piedra caliza, sin ornamentos, se inspira en los característicos edificios cercanos diseñados por Frank Lloyd Wright y Howard Van Doren Shaw. El luminoso interior, acentuado por las grandes ventanas y las paredes blancas, es el marco perfecto para resaltar la colección de arte del propietario.

Skybridge
at One North Halsted

Perkins+Will
Samartano & Company (SE)

2002
1 North Halsted Street
West Loop

www.perkinswill.com
www.skybridgechicago.com

This first residential tower by Perkins+Will architect Ralph Johnson is arranged so that each unit has access to views, natural light, and private outdoor spaces. The 39-story building, divided into distinct masses with elements of glass and concrete, towers above the low-rise structures of the surrounding Greek Town neighborhood.

Der erste Wohnturm des Perkins+Will-Architekten Ralph Johnson ist so angelegt, dass jede Einheit über Ausblick, natürliches Licht und private Außenbereiche verfügt. Das 39-stöckige Gebäude ist mit Elementen aus Glas und Beton klar gegliedert und überragt die Flachbauten von Greek Town, die es umgeben.

La première tour d'habitation de l'architecte Ralph Johnson de Perkins+Will est conçue de façon à ce que chaque unité dispose d'une vue, de la lumière naturelle et de domaines extérieurs privés. Comptant 39 étages, le bâtiment est clairement structuré avec des éléments en verre et en béton et surplombe les bâtiments plats de Greek Town qui l'entourent.

El primer rascacielos de viviendas del arquitecto Ralph Johnson de Perkins+Will está dispuesto de tal forma que todas las unidades disfrutan de vista, de luz natural y de espacios exteriores privados. El edificio, de 39 plantas, está claramente subdividido por los elementos de cristal y hormigón, y supera en altura a las construcciones colindantes de Greek Town.

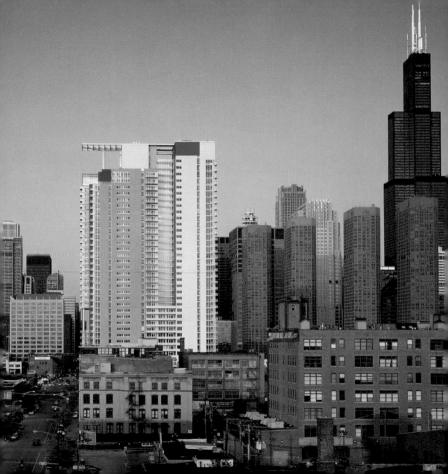

Outer Circle

Jordan Mozer and Associates, Ltd.

1997
860 West Evergreen Avenue
Goose Island

www.mozer.com

The design reflects the company's desire to democratize the workplace and lively interactions between white-collar and blue-collar employees. Everyone entering the building is exposed to the busy shop floor; the assembly line, which produces sandwich boxes and freezer bags, occupies the center atrium.

Das Design spiegelt den Wunsch des Unternehmens nach Demokratisierung des Arbeitsplatzes und regem Austausch zwischen Angestellten und Arbeitern wider. Beim Betreten des Gebäudes ist man sofort mitten in der geschäftigen Produktionshalle; das Fließband mit den hier produzierten Butterbrotdosen und Kühltaschen nimmt das zentrale Atrium ein.

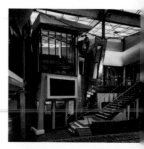

Avec ce design, l'entreprise montre qu'elle souhaite une démocratisation du lieu de travail et un échange intense entre les employés et les ouvriers. En pénétrant dans le bâtiment, on se trouve immédiatement au centre de l'atelier de production en activité ; la chaîne sur laquelle circulent les boîtes pour tartines et les glacières produites ici occupe l'atrium central.

El diseño refleja el deseo de la empresa de democratizar el lugar de trabajo y de animar el intercambio entre empleados y trabajadores. Al entrar en el edificio, el visitante se encuentra directamente en la sala de producción; la cadena de fabricación con los productos que aquí se fabrican, envases para sandwiches y bolsas de conservación, ocupa el atrio central.

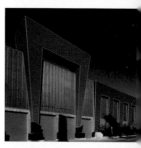

40

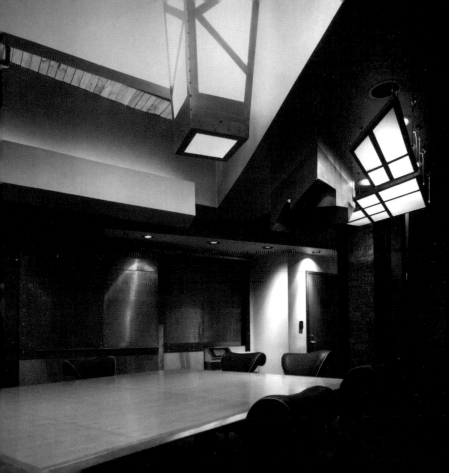

UBS Tower

Lohan Caprile Goettsch Architects
Thornton Tomasetti Engineers (SE)

2001
1 North Wacker Drive
Loop

www.lohan.com
www.ubs.com

UBS Tower is the first speculative office tower built in downtown since the 1990s. It is designed to accommodate changes in technology as well as new configurations of tenants.

Der UBS Tower ist der erste nicht in seiner Nutzung im Voraus festgelegte Büroturm, der seit den 1990er-Jahren in Downtown errichtet wurde. Er ist so konzipiert, dass er technologische Veränderungen sowie neue Mieterkonstellationen in Einklang bringt.

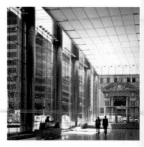

La UBS Tower est la première tour de bureaux construite depuis les années 90 à Downtown dont l'utilisation n'a pas été déterminée au préalable. Elle est conçue de façon à concilier les modifications technologiques avec les nouvelles constellations de locataires.

La UBS Tower es la primera torre de oficinas levantada en el centro desde la década de 1990, donde su uso no se fijó por adelantado. Fue concebida de modo que fuera posible integrar los cambios tecnológicos y las nuevas constelaciones de los inquilinos.

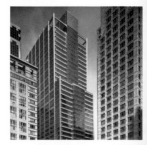

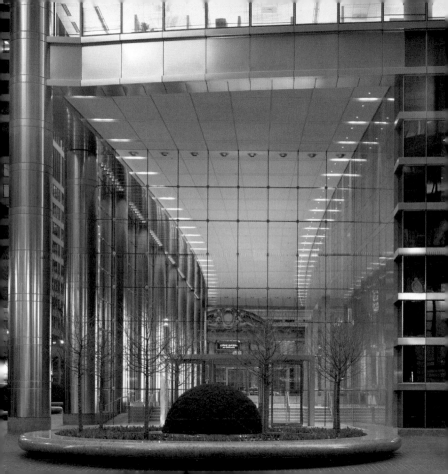

Shure Headquarters

Murphy/Jahn
Peller and Associates (SE)

2000
5800 West Touhy Avenue
Niles

www.murphyjahn.com
www.shure.com

The building is a primo example of Murphy/Jahn's idea of "archineering". This concept is achieved in this space by pushing the limits of integrated building technology, exploring the aesthetic and functional possibilities of transparency, and increasing the overall performance of the building.

Das Gebäude ist ein Paradebeispiel für das Konzept des „Archi-Neering" von Murphy und Jahn. Erreicht wurde dies hier, indem man bis an die Grenzen der integrierten Gebäudetechnologie ging, die ästhetischen und funktionellen Möglichkeiten der Transparenz auslotete und die Wirtschaftlichkeit des Gebäudes insgesamt erhöhte.

Cet édifice est un exemple révélateur du concept « Archi-Neering » de Murphy et de Jahn. Ceci a été obtenu en allant aux limites de la technologie intégrée du bâtiment, analysant les possibilités esthétiques et fonctionnelles de la transparence et augmentant en général la rentabilité du bâtiment.

El edificio es un clásico ejemplo del concepto "Archi-Neering" de Murphy y Jahn. Aquí, la convergencia entre la arquitectura y la ingeniería se consiguió llevando hasta los límites la tecnología del edificio, aprovechando al máximo las posibilidades estéticas y funcionales de la transparencia y elevando la rentabilidad del edificio.

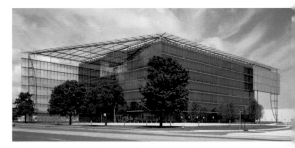

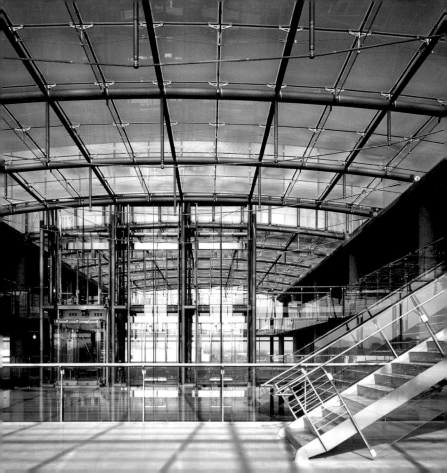

Unilever

Gensler

2003
205 North Michigan Avenue
River North

www.gensler.com
www.unileverna.com

This interior conveys the company's image directly and indirectly through spatial composition. Wall graphics and niches provide opportunities for product displays and advertising, while the bright colors and the reception area impart a sense of physical pampering found at a spa.

Das Interieur ist so angelegt, dass das Image des Unternehmens durch räumliche Komposition sowohl direkt als auch indirekt vermittelt wird. Wandbilder und Nischen bieten Raum für Produktdisplays und Werbung, während die leuchtenden Farben und die Empfangshalle das Gefühl vermitteln, dass wie in einem Wellness-Center für das körperliche Wohl gesorgt wird.

L'intérieur est conçu de façon à ce que la composition spatiale des pièces confère directement et indirectement l'image de la société. Les images murales et les niches permettent d'exposer produits et publicité, alors que les couleurs chatoyantes et le hall de réception donnent l'impression qu'on accorde ici autant d'importance au bien-être du corps que dans un centre wellness.

El interior se ha concebido de modo que la composición espacial refleja la imagen de la empresa de forma directa e indirecta. Los cuadros y las esquinas ofrecen espacio para los expositores de los productos y los carteles publicitarios, y los luminosos colores y la entrada transmiten la sensación de que, como en un centro de wellness, se busca el bienestar del cuerpo.

46

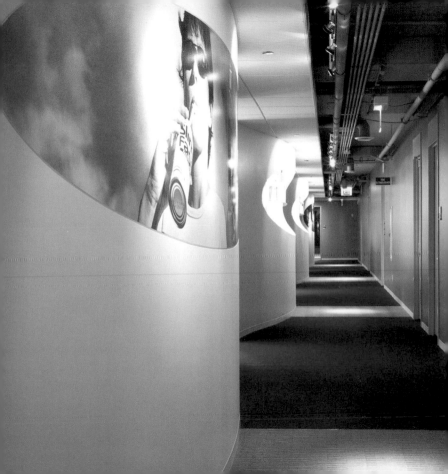

Urban Innovations
Corporate Offices

Eva Maddox Branded Environments

1997
445 North Wells Street
Suite 200
River North

www.evamaddox.com
www.urbaninnovations.com

The offices were intended to express the company's identity as an environmentally conscious leasing company that owns primarily lofts. By creating a welcoming, high-tech, flexible space for their own offices, the company hoped to demonstrate the possibilities of a green loft space to their clients.

Die Büros sollten die Identität des Unternehmens als umweltbewusste Leasinggesellschaft vermitteln, die in erster Linie Lofts besitzt. So errichtete das Unternehmen für seine eigenen Büros ein einladendes, flexibles Hightech-Gebäude in der Hoffnung, seinen Kunden die Möglichkeiten umweltfreundlicher Loftflächen zu verdeutlichen.

Les bureaux sont censés mettre en valeur l'identité de l'entreprise, possédant avant tout des lofts, comme une société de leasing consciente des problèmes d'écologie. L'entreprise construisit ainsi pour ses propres bureaux un bâtiment high-tech attrayant et flexible dans l'espoir de présenter à ses clients les possibilités offertes par des surfaces écologiques pour lofts.

Las oficinas querían transmitir la identidad de la empresa como una sociedad dedicada al alquiler con conciencia medioambiental que posee, en primera línea, lofts. Por eso, para sus propias oficinas la firma quiso un edificio de alta tecnología flexible y sugerente, con el que esperaban poder dar a conocer a sus clientes las posibilidades de los lofts ecológicos.

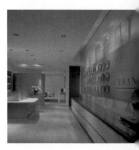

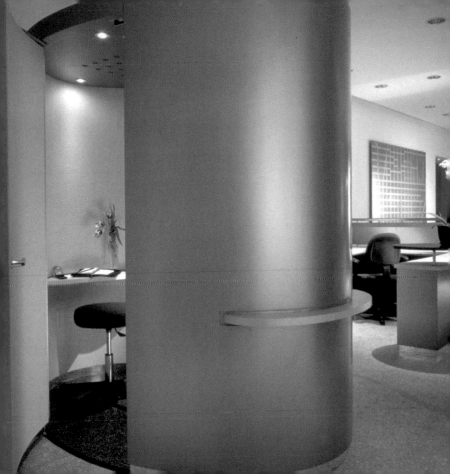

Squark

Brininstool + Lynch
Lyle Haag Engineering (SE)

2001
1144 West Washington Boulevard
West Loop

www.brininstool-lynch.com

Thooo officoo are a reutilization project undertaken for Squark—a small group of theoretical physicists. The space is designed to comfortably house the company's employees and clients while also providing suitable accommodation for the technical equipment.

Cet immeuble bureau est un projet de recyclage qui fut réalisé pour Squark, un petit groupe de physiciens théoriques. Sa conception offre suffisamment de place à la fois aux employés et aux clients de l'entreprise et constitue en même temps un lieu approprié permettant d'installer les équipements techniques.

Dieses Bürogebäude ist ein Wiederverwertungsprojekt, das für Squark – eine kleine Gruppe von theoretischen Physikern – durchgeführt wurde. Es ist so angelegt, dass es sowohl den Angestellten als auch den Kunden des Unternehmens genug Platz bietet und gleichzeitig eine geeignete Unterbringungsmöglichkeit für die technische Ausrüstung darstellt.

Este edificio de oficinas es un proyecto reciclado diseñado para Squark, un pequeño grupo de físicos teóricos. Se ha estructurado de tal forma que ofrece espacio suficiente para los empleados y los clientes de la empresa, al mismo tiempo que posibilita el almacenamiento adecuado del equipamiento técnico de la firma.

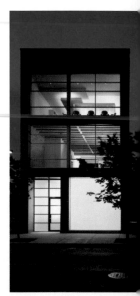

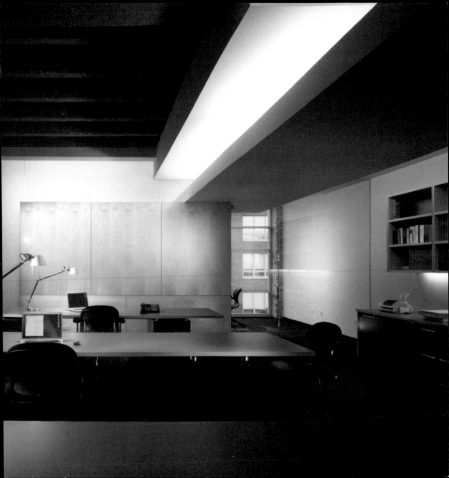

Chinese American Community Center

Studio/ Gang /Architects
Thornton Tomasetti Engineers (SE)

2004
2141 South Tan Court
Chinatown

www.studiogang.net
www.caslservice.org

The vertical orientation of the sunshade lattice recalls Chinese lanterns; the exterior cladding of titanium shingles appear as dragon scales. The interior, accented with reds, greens, and yellows, is designed to encourage intergenerational interaction.

Die vertikale Ausrichtung des Sonnenblendengitters erinnert an chinesische Laternen, die Außenverkleidung aus Titanschindeln an Drachenschuppen. Das Interieur, akzentuiert durch Rot, Grün und Gelb, soll die Interaktion zwischen den Generationen fördern.

La disposition verticale de la grille composée de pare-soleil rappelle les lanternes chinoises, le revêtement externe réalisé à partir de bardeaux en titane rappelle les écailles de dragon. L'intérieur, accentué de rouge, de vert et de jaune, est censé encourager l'interaction entre les générations.

La disposición vertical de la pantalla de protección solar recuerda a los farolillos chinos, y el revestimiento exterior de tablillas de titanio, a las escamas de un dragón. El interior, acentuado por los colores rojo, verde y amarillo, quiere fomentar la interacción entre las generaciones.

University of Chicago Graduate School of Business

Rafael Viñoly Architects, PC.
Dewhurst Macfarlane and Thornton Tomasetti Engineers (SE)

2004
5807 South Woodlawn Avenue
Hyde Park

www.rvapc.com
www.uchicago.edu

This building is a modern rointerpretation of the Gothic architectural vocabulary of the campus. The vertically oriented Winter Garden, with its glass-covered vaulted space supported by tree-like steel columns, is contrasted by the surrounding horizontal band of classroom space, offices, and computer labs.

Dieses Gebäude ist eine Neuinterpretation des gotischen Architekturvokabulars, das den Campus prägt. Der vertikal angelegte Wintergarten mit seinem gewölbten und von baumähnlichen Stahlsäulen gestützten Glasdach bildet einen Kontrast zu dem umliegenden horizontalen Gürtel aus Klassenzimmern, Büros und Computerräumen.

Ce bâtiment est une nouvelle interprétation du vocabulaire d'architecture gotique qui marque le campus. La jardin d'hiver, conçu à la verticale avec son toit en verre voûté et soutenu par des colonnes en acier ressemblant à des arbres constitue un contraste avec la ceinture horizontale environnante comprenant salles de classe, bureaux et salles informatiques.

Este edificio es una reinterpretación del vocabulario arquitectónico gótico que caracteriza al campus. La construcción vertical del invernadero, con su cubierta de cristal abovedada y soportada por columnas de acero similares a árboles, contrasta con el cinturón de líneas horizontales formado por las aulas, las oficinas y las salas de ordenadores.

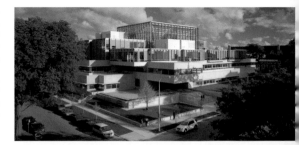

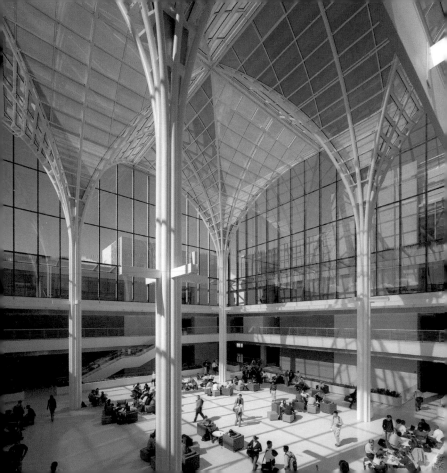

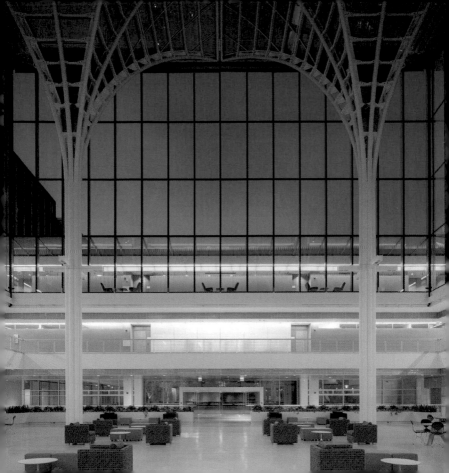

Akiba-Schechter
Jewish Day School

John Ronan Architect
Robert L. Miller Associates (SE)

2004
5235 South Cornell Avenue
Hyde Park

www.jrarch.com
home.earthlink.net/
~akibaschechter/

The exterior of this two-story elementary school is composed of precast concrete and oxidized copper; materials throughout the interior reflect a similar interest in texture and color. Hebrew characters cast in the concrete panels signal a larger cultural context for the school.

Die Fassade dieser zweistöckigen Grundschule besteht aus Betonfertigteilen und oxidiertem Kupfer; die im Interieur verwendeten Materialien spiegeln eine ähnliche Textur und ähnliche Farben wider. In Betonplatten gegossene hebräische Buchstaben verdeutlichen den kulturellen Anspruch der Schule.

La façade de cette école primaire sur deux étages est composée de pièces préfabriquées en béton et de cuire oxydé ; les matériaux utilisés à l'intérieur reflètent une texture semblable et des couleurs semblables. Des lettres hébraïques fondues dans des plaques de béton caractérisent l'exigence culturelle de l'école.

La fachada de este colegio de primaria de dos plantas está formada por elementos prefabricados de hormigón y cobre oxidado. En el interior, los materiales empleados reflejan una textura y unos colores similares. Las letras en hebreo grabadas en las placas de hormigón ilustran la pretensión cultural del colegio.

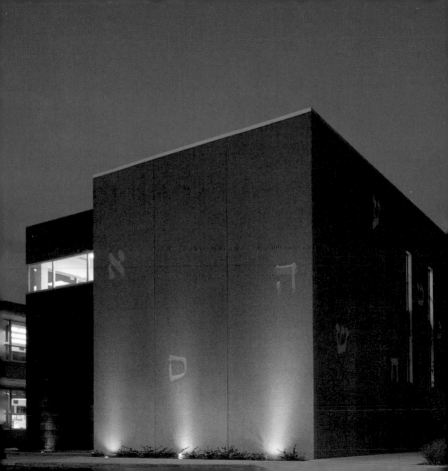

Hyde Park Art Center

Garofalo Architects
Douglas Garofalo, FAIA, Andrew Schachman, Randy Kober

2006
5307 South Hyde Park Boulevard
Hyde Park

www.garofaloarchitects.com
www.hydeparkart.org

The new facilities for the Hyde Park Art Center will re-inhabit an old masonry structure and engage the community with the addition of a glass-and-steel "digital façade". The building façade itself becomes a surface for artistic expression, providing opportunities for electronic exhibition space.

Die neuen Anlagen für das Hyde Park Art Center werden ein altes gemauertes Gebäude wieder beleben und der Stadt darüber hinaus eine „digitale Fassade" aus Glas und Stahl liefern. Die Gebäudefassade selbst bietet Raum für Kunst und stellt gleichzeitig eine elektronische Ausstellungsfläche dar.

Les nouvelles constructions pour le Hyde Park Art Center vont rendre la vie à un ancien bâtiment muré et fournir de plus à la ville une « façade numérique » en verre et en acier. La façade même du bâtiment offre de la place pour l'art et offre parallèlement une surface d'exposition électronique.

Un viejo edificio tapiado vuelve a cobrar vida a través de las nuevas instalaciones del Hyde Park Art Center, al mismo tiempo que la ciudad obtiene una "fachada digital" de vidrio y acero. La misma fachada del edificio ofrece además un espacio para el arte y puede actuar como superficie electrónica de exposición.

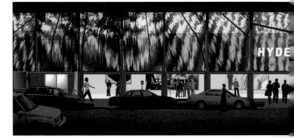

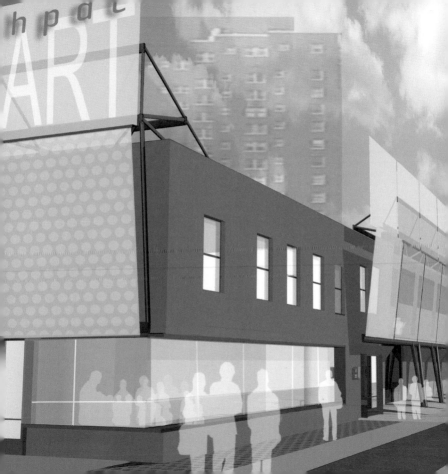

McCormick Tribune Campus Center

Office for Metropolitan Architecture
Rem Koolhaas / Ole Sheeren / Ellen van Loon / Joshua Ramus
Arup London (SE)

2003
3201 South State Street
IIT

www.oma.nl
www.iit.edu

The entrance is marked by circular pictograms that merge into a larger image of Mies van der Rohe. This homage to IIT's campus designer, however, is contradicted by the dynamic, complex, and intense design that characterizes the rest of the structure.

Der Eingang wird durch kreisförmige Piktogramme geschmückt, die zusammen ein größeres Bild von Mies van der Rohe ergeben. Dieser Hommage an den Designer des IIT Campus wirkt jedoch das dynamische, komplexe und intensive Design entgegen, das den übrigen Teil des Gebäudes charakterisiert.

L'entrée est décorée par des pictogrammes en forme de cercles qui créent ensemble un grand portrait de Mies van der Rohe. Cet hommage au designer du IIT Campus s'oppose toutefois au design dynamique, complexe et intense qui caractérise la partie restante du bâtiment.

La entrada está adornada con pictogramas circulares que, juntos, forman un gran cuadro de Mies van der Rohe. Este homenaje al diseñador del IIT Campus establece un contrapunto al diseño dinámico, complejo e intenso que caracteriza al resto del edificio.

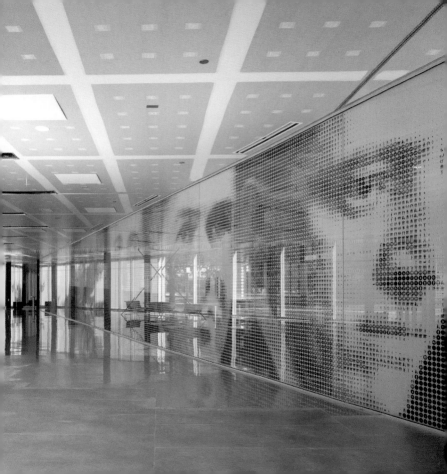

Art Institute of Chicago Expansion

Renzo Piano Building Workshop

2008
37 South Wabash Avenue
Loop

www.rpbw.com
www.artic.edu

The expansion will create an entrance on Monroe Street and a link to Millennium Park while housing the museum's collections, educational facilities, and public spaces. The design features functionally flexible façades and a "flying carpet" roof structure based on fractal geometry.

Der Erweiterungsbau lässt einen Eingang auf der Monroe Street und eine Verbindung zum Millennium Park entstehen. Er beherbergt Sammlungen des Museums, Bildungseinrichtungen und öffentliche Flächen. Das Design weist funktionell flexible Fassaden auf, sowie eine auf fraktaler Geometrie basierende Dachstruktur, die einem fliegenden Teppich nachempfunden ist.

La partie agrandie crée une entrée sur la Monroe Street et un lien vers le Millennium Park. Il héberge des collections du musée, des installations culturelles et des lieux publics. Le design présente des façades flexibles selon leur fonction ainsi qu'un toit dont la structure est basée sur la géométrie fractale et qui imite un tapis volant.

La ampliación del edificio abre una entrada por la Monroe Street y una conexión con el Millennium Park. El instituto alberga las colecciones del museo, centros de formación y superficies públicas. El diseño presenta fachadas funcionalmente flexibles, además de una estructura de la cubierta basada en una geometría fractal similar a una alfombra voladora.

66

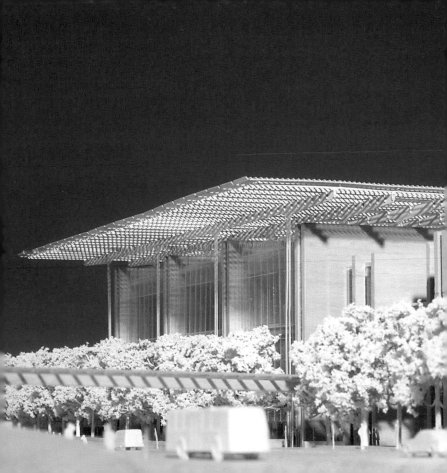

CitySpace Gallery
Chicago Architecture Foundation

Skidmore, Owings & Merrill LLP

2001
224 South Michigan Avenue
Loop

www.som.com
www.architecture.org

The minimalist interior design of the Chicago Architecture Foundation's CitySpace Gallery is contained within the historic Santa Fe building in downtown Chicago. Sleek, white, curved walls with bands of indirect lighting provide a neutral backdrop for exhibitions relating to the city's built environment.

Die CitySpace Gallery der Chicagoer Architekturstiftung mit ihrem minimalistischen Innendesign befindet sich im historischen Santa Fe Building in Downtown Chicago. Glatte, weiße, gekrümmte Mauern mit indirekter Beleuchtung bieten einen neutralen Hintergrund für Ausstellungen über die architektonische Entwicklung der Stadt.

La CitySpace Gallery de la fondation d'architecture de Chicago avec son design intérieur minimaliste se trouve dans le Santa Fe Building historique à Downtown Chicago. Les murs lisses, blancs et incurvés avec un éclairage indirect offrent un décor neutre pour les expositions sur l'évolution architecturale de la ville.

La CitySpace Gallery, de la Fundación de Arquitectura de Chicago, se encuentra, con su diseño interior de estilo minimalista, en el histórico edificio Santa Fe en el centro de Chicago. Los muros blancos, lisos y arqueados, ofrecen con su iluminación indirecta un fondo neutro para exposiciones sobre el desarrollo arquitectónico de la ciudad.

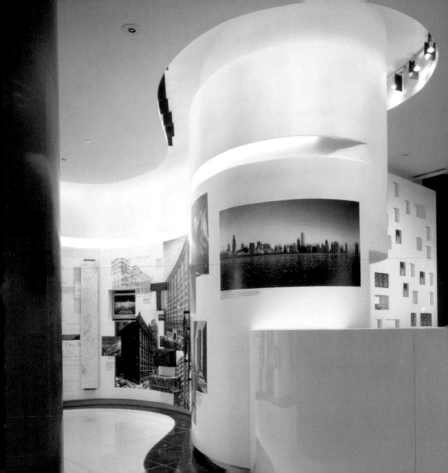

Joan W. and Irving B. Harris Theater for Music and Dance

Hammond Beeby Rupert Ainge, Inc.
Thornton Tomasetti Engineers (SE)

2003
205 East Randolph Street
Millennium Park

www.hbra-arch.com
www.madtchi.com

The two-story glass façade at the northern end of the Millennium Park is not only a signboard but also the entrance to the theater. An illuminated entrance at the front of the building leads visitors down to a 1,500-seat, state-of-the-art performance venue.

Die zweistöckige Glasfassade am nördlichen Ende des Millennium Park ist gleichzeitig Reklameschild und Eingang für das Theater. Der beleuchtete Eingang an der Vorderseite des Gebäudes führt die Besucher hinab zu einem modernen Aufführungsort mit 1500 Sitzplätzen.

La façade en verre sur deux étages à l'extrémité nord du Millennium Park est à la fois l'enseigne publicitaire et l'entrée du théâtre. A travers l'entrée éclairée sur le devant du bâtiment, les visiteurs descendent vers un lieu d'exposition moderne avec 1500 places assises.

La fachada de vidrio de dos plantas que se encuentra en el extremo norte del Millennium Park es simultáneamente imagen publicitaria y entrada del teatro. La entrada, iluminada y situada en la cara anterior del edificio, conduce a los visitantes hacia abajo, donde se encuentra un teatro moderno con sitio para 1.500 asientos.

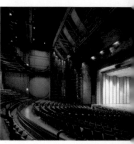

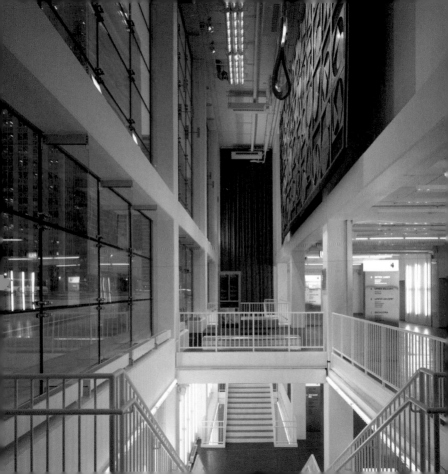

Adler Planetarium & Astronomy Museum Sky Pavilion

Lohan Caprile Goettsch Architects

1998
1300 South Lakeshore Drive
Museum Campus

www.lohan.com
www.adlerplanetarium.org

The renovation and extension improved the original 1930s planetarium with spectacular views. A half-ring of new exhibition space and a lower level auditorium wraps around the old dome. The slanted glass roof of the upper gallery opens up the sky and skyline to visitors.

Die Renovierung und Ergänzung bereicherte das aus den 1930er-Jahren stammende Planetarium um spektakuläre Ausblicke. Um die alte Kuppel herum erstreckt sich ein Halbkreis aus neuen Ausstellungsflächen und einem tiefer liegenden Auditorium. Das schräge Glasdach der oberen Galerie gibt den Besuchern den Blick auf Himmel und Skyline frei.

Avec la rénovation et ce complément, le planétarium, construit dans les années 30, fut enrichi de vues spectaculaires. Autour de l'ancienne coupole s'étend un demi-cercle comprenant de nouvelles surfaces d'exposition et un auditorium au niveau inférieur. Le toit en verre en biais de la galerie supérieure permet aux visiteurs d'admirer le ciel et la Skyline.

Con el saneamiento y la ampliación del planetario, de la década de 1930, se consiguió dotar al edificio de espectaculares vistas. Entorno a la vieja cúpula se extiende un semicírculo con las nuevas superficies de las exposiciones y un auditorio a un nivel bajo. La construcción de vidrio de la cubierta de la galería superior permite a los visitantes ver el cielo y el horizonte.

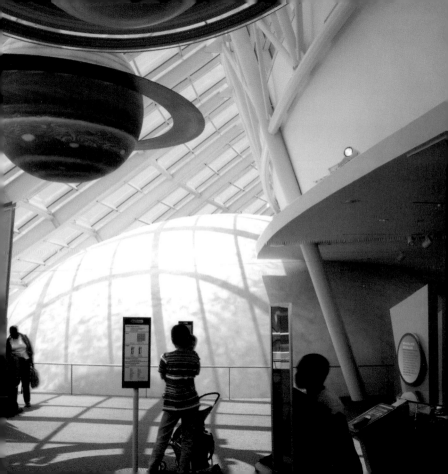

Jubilee Family Resource Center

Ross Barney + Jankowski Architects
Rubinos and Mesia (SE)

2001
3701 West Ogden Avenue
North Lawndale

www.rbjarchitects.com

The design of this childcare center emphasizes the cultural heritage of the predominantly African-American community. Various colors are woven together to form patterns on the façade and floor reminiscent of African textiles. Inside colored spaces surround a grass-covered central courtyard that serves as a children's play area.

Das Design dieses Kinderhorts betont das kulturelle Erbe der überwiegend afroamerikanischen Gemeinde. Auf Fassade und Boden setzen sich verschiedene Farben zu Mustern zusammen, die an afrikanische Stoffe erinnern. Im Innern umgeben bunte Flächen einen grasbewachsenen Hof, der als Kinderspielplatz dient.

Le design de cette garderie d'enfants met en valeur l'héritage culturel de la communauté principalement afro-américaine. Sur la façade et au sol, différentes couleurs s'assemblent pour former des motifs qui rappellent des tissus africains. A l'intérieur, des surfaces bigarrées entourent une cour herbeuse qui sert d'espace de jeu pour les enfants.

El diseño de esta guardería subraya la herencia cultural de esta comunidad mayoritariamente afroamericana. En la fachada y en los suelos se mezclan diferentes colores formando dibujos que recuerdan a las telas africanas. En el interior, un jardín rodeado de superficies de colores, se emplea como patio para los niños.

74

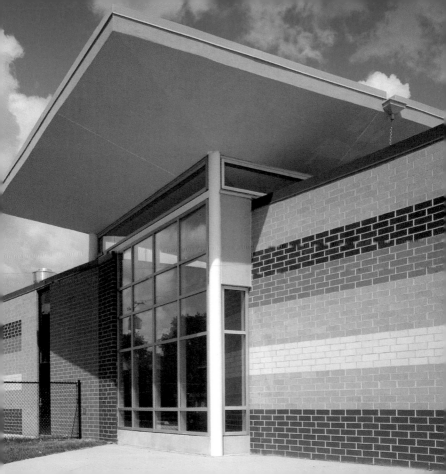

Benito Juarez High School Performing Arts Center

URBANWorks, Ltd. – Design Architects
OWP&P – Managing Architects

2007
2150 South Laflin Street
Pilsen

www.urbanworksarchitecture.com

This renovation and addition to a high school in a largely Latino neighborhood is inspired by the aesthetics and ecology of the Copper Canyon region in Chihuahua, Mexico. The earth-toned materials and vertical orientation of the buildings reflect the layering of ecosystems in that region.

Inspiration für diese Sanierung und Ergänzung einer High School in einer größtenteils lateinamerikanisch besiedelten Gegend war die Ästhetik und Ökologie der Copper-Canyon-Region im mexikanischen Chihuahua. Die erdfarbenen Materialien sowie die vertikale Ausrichtung der Gebäude spiegeln die Schichtung der Ökosysteme in jener Region wider.

Cette réhabilitation et ce complément d'une High School dans une région comptant une population majoritairement latino-américaine est inspirée de l'esthétique et de l'écologie de la région Copper-Canyon dans le Chihuahua, au Mexique. Les matériaux de couleur terre, ainsi que la disposition verticale du bâtiment, reflètent la stratification d'écosystèmes dans cette région.

La estética y la naturaleza de la zona del cañón del Cobre, en Chihuahua, han sido la inspiración para la rehabilitación y la ampliación de esta escuela superior ubicada en un barrio habitado mayoritariamente por latinoamericanos. Los materiales de color tierra y la disposición vertical de los edificios reflejan la estratificación de los ecosistemas en aquella región.

Bengt Sjostrom /
Starlight Theater

Studio/ Gang /Architects

2004
3301 North Mulford Road
Rockford

www.studiogang.net
www.rvcstarlight.com

The dynamic structure of the Starlight Theater literally opens up to the night sky, providing theatergoers with a spectacular view of the heavens. The enormous, mobile "petals" of the roof are an elegant technological and aesthetic solution for this small campus theater in Rockford, Illinois.

Dieses kleine Campustheater in Rockford (Illinois) besitzt eine dynamische Dachstruktur aus riesigen beweglichen „Blüten-blättern", die den Besuchern buchstäblich einen spektakulä-ren Blick auf den Nachthimmel eröffnen. Sowohl technisch als auch ästhetisch eine äußerst ele-gante Lösung.

Ce petit théâtre de campus à Rockford (Illinois) possède un toit à la structure dynamique fait de « pétales » géantes et mobiles qui offrent littéralement aux visiteurs une vue specta-culaire sur le ciel nocturne. Une solution extrêmement élégante, autant du point de vue tech-nique qu'esthétique.

La estructura dinámica de la cu-bierta de este pequeño teatro universitario en Rockford (Illi-nois), está formada por "péta-los" móviles que, al abrirse, permiten a los espectadores disfrutar de una espectacular vista del cielo nocturno. Se trata de una solución muy ori-ginal, tanto desde el punto de vista estético como técnico.

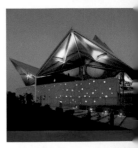

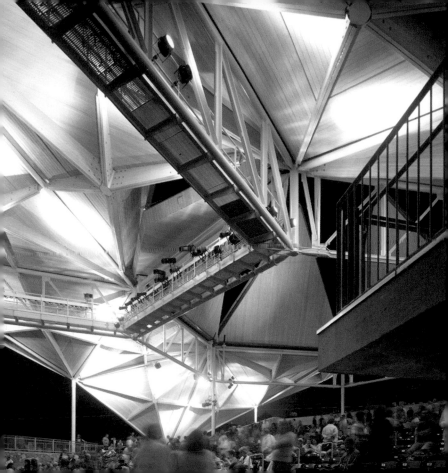

35th Street Bridge and Station

Gensler

2003
16 East 35th Street
Bridgeport/Bronzeville

www.gensler.com
www.chicago-l.org/stations/35-bronze-IIT.html

The renovation of the station provides train passengers with a safe, well-lit entry point to Bronzeville, the Illinois Institute of Technology, and U.S. Cellular Field. A light framework of projecting steel canopies creates a plaza that reconnects two neighborhoods.

Die Renovierung der Haltestelle bietet Zugreisenden einen sicheren, gut beleuchteten Zugang nach Bronzeville, zum Illinois Institute of Technology und zum U.S. Cellular Field. Ein leichter Rahmen aus vorstehenden Stahlbaldachinen lässt einen Platz entstehen, der eine neue Verbindung zwischen zwei Stadtvierteln schafft.

La rénovation de la station offre aux voyageurs en train un accès sûr et bien éclairé vers Bronzeville, vers le Illinois Institute of Technology et le U.S. Cellular Field. Un leger cadre de baldaquins en acier en saillie fait apparaître une place, créant un nouveau lien entre deux quartiers de la ville.

Las reformas en la parada ofrecen a los viajeros del tren un acceso seguro y bien iluminado al vecindario Bronzeville, al Illinois Institute of Technology y al U.S. Cellular Field. Un marco ligero de baldaquinos de acero sobresalientes crea una plaza que establece una nueva conexión entre dos barrios.

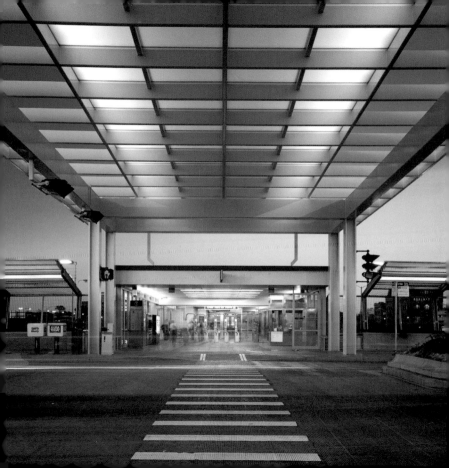

Ping Tom Fieldhouse

Schroeder,Murchie,Niemiec,Gazda-Auskalnis architects

not determined
Ping Tom Memorial Park
Chinatown

www.smlarch.com
www.chicagoparkdistrict.com

The architects of the second stage of Ping Tom Memorial Park were confronted with the problem of trying to fit into the context of Chinatown without constructing a pagoda. The new building will contain multiple gymnasiums, swimming pool, and meeting spaces—and provide a connection to the nearby river.

Bei der zweiten Phase des Ping Tom Memorial Park stellte sich den Architekten die Herausforderung, ein Gebäude zu entwerfen, das zu Chinatown passt, ohne dabei eine Pagode zu bauen. Das neue Bauwerk wird mehrere Sporthallen, einen Swimmingpool sowie Versammlungsräume beherbergen – und gleichzeitig eine Verbindung zum nahe gelegenen Fluss darstellen.

Pour la seconde phase du Ping Tom Memorial Park, les architectes firent face au défi de concevoir un bâtiment qui s'accorde à la Chinatown, sans pour autant construire une pagode. La nouvelle construction hébergera plusieurs gymnases, une piscine ainsi que des salles de réunion, et créera en même temps un lien avec le fleuve situé tout près.

Con la segunda fase del Ping Tom Memorial Park, los arquitectos se enfrentaron al desafío de diseñar una edificación que se integrase en la Chinatown, pero que no fuera una pagoda. La nueva construcción albergará gimnasios multiples, una piscina y salas de reuniones, al mismo tiempo que establecerá una conexión con el cercano río.

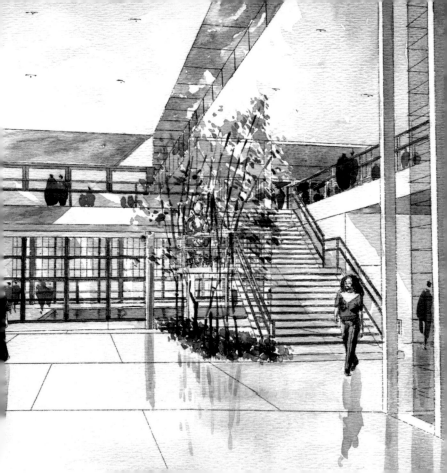

Ford Calumet Environmental Center, "Best Nest"

Studio/ Gang /Architects

2006
130th Street & Torrance Avenue
Hegewisch

www.studiogang.net

Studio Gang's "Best Nest" design was the winner of a competition to build the Ford Calumet Environmental Center on an old industrial site on the city's far south side. The design draws on the metaphor of nest-making to reflect ideas about material reuse and natural design strategies.

Das „Best-Nest-Design" von Studio Gang war der Sieger eines Wettbewerbs um die Erbauung des Ford Calumet Environmental Center an einem alten Industriestandort im südlichsten Teil der Stadt. Das Design setzt auf die Metapher des Nestbauens, um das Konzept der Material-Wiederverwertung und Naturdesignstrategien widerzuspiegeln.

Le design « Best Nest » de Studio Gang fut le vainqueur d'un concours prévoyant la construction du Ford Calumet Environmental Center près d'un ancien site industriel dans la partie sud de la ville. Le design s'appuie sur la métaphore de la construction du nid pour refléter le concept du recyclage des matériaux et les stratégies de design naturel.

El diseño "Best Nest" del Studio Gang fue el ganador de un concurso para la edificación del Ford Calumet Environmental Center en un antiguo emplazamiento industrial, en la parte sur de la ciudad. El diseño apuesta por la metáfora de la construcción de nidos para reflejar la reutilización de los materiales y las estrategias arquitectónicas de la Naturaleza.

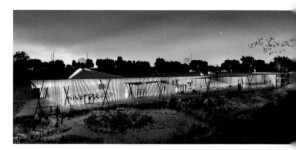

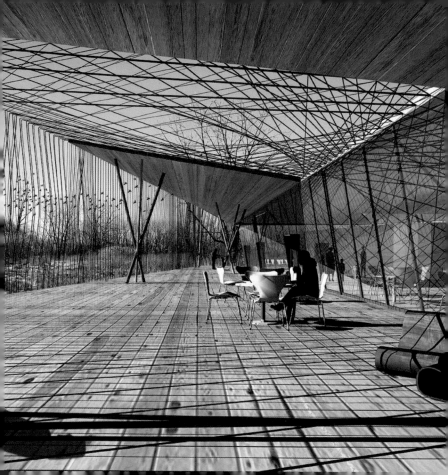

Jay Pritzker Pavilion

Gehry Partners, LLP

2004
201 East Randolph Street
Millennium Park

www.foga.com
www.millenniumpark.org/pritzker

This main attraction in Millennium Park is a typical Gehry hybrid of sculpture and architecture. The stage is framed by an explosive array of stainless steel panels that appear to be peeling back from the central opening. A delicate trellis with suspended speakers extends over the seating area.

Diese Hauptattraktion des Millennium Park ist ein typischer Gehry-Hybrid aus Skulptur und Architektur. Die Bühne wird eingerahmt von einer explosiven Anordnung von Edelstahlplatten, die den Anschein erwecken, sich von der Bühne weg nach hinten „abzuschälen". Über den Sitzbereich zieht sich ein zierliches Gitter mit aufgehängten Boxen.

Cette attraction principale du Millennium Park est un hybride typique de Gehry composé de sculpture et d'architecture. La scène est encadrée d'une disposition explosive de plaques en inox qui donnent l'impression de « se détacher » de la scène vers l'arrière. Une jolie grille dotée d'enceintes suspendues s'élève au-dessus des places assises.

La principal atracción del Millennium Park es una típica construcción híbrida de Gehry de escultura y arquitectura. El escenario está enmarcado por una impresionante estructura de placas de acero que producen la impresión de separarse del escenario conforme se alejan hacia atrás. Sobre la zona de los asientos se extiende una malla delgada de donde cuelgan los altavoces.

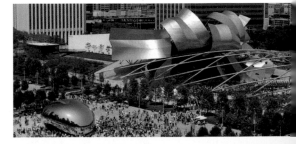

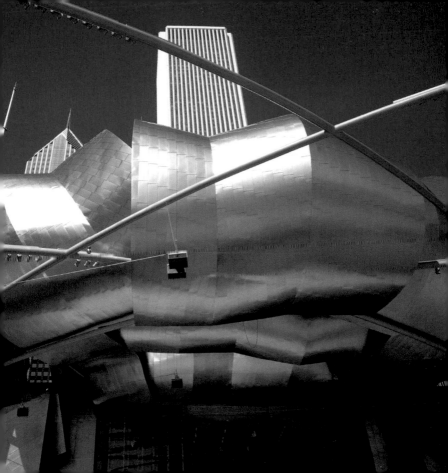

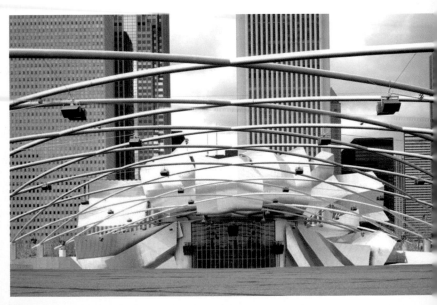

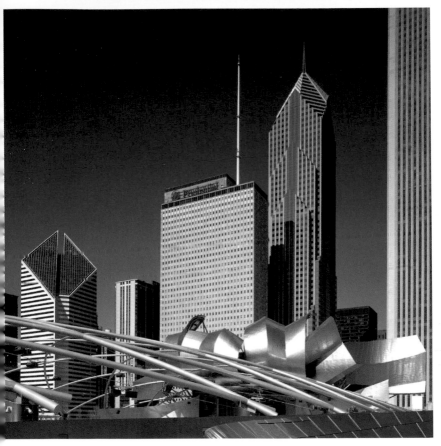

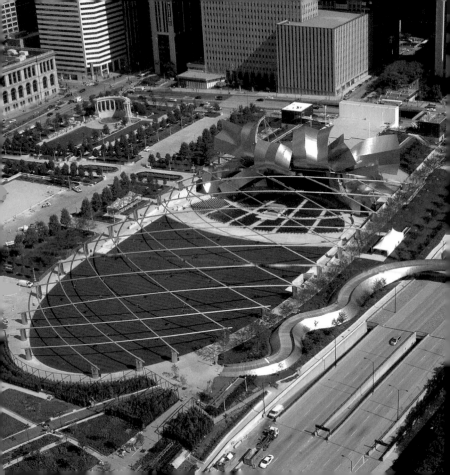

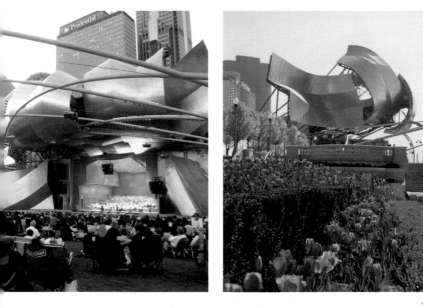

The Crown Fountain

Jaume Plensa (artist)

2004
201 East Randolph Street
Millennium Park

www.millenniumpark.org/crown

Boasting 50 ft glass block towers on each end of a 232 ft pool, this fountain by the Spanish sculptor combines the use of water, light, and glass with this unique location. Changing video images of faces appear on the towers as water cascades from the top of each.

Bei diesem Brunnen auc zwei 15 Meter hohen Glasblocktürmen an den Enden eines knapp 71 Meter langen Wasserbeckens kombiniert der spanische Bildhauer die Wirkung von Wasser, Licht und Glas. Auf den Türmen erscheinen sich verändernde Videobilder von Gesichtern, während von den Turmspitzen Wasserkaskaden herabstürzen.

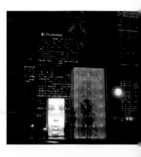

Pour cette fontaine composée de deux tours en verre de 15 mètres de haut situées aux extrémités d'un bassin de près de 71 mètres de long, le sculpteur espagnol a associé l'effet de l'eau, de la lumière et du verre. Des images vidéo alternantes représentant des visages apparaissent sur les tours, pendant que des cascades d'eau dévalent du haut des tours.

El diseño de esta fuente de dos bloques de vidrio de 15 metros de altura y situados en cada uno de los extremos de una taza de 71 metros de largo, el escultor español combina los efectos del agua, la luz y el cristal. En las superficies de las torres de vidrio se proyectan imágenes de caras, mientras que desde la parte superior de cada una de ellas cae el agua en cascada.

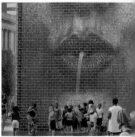

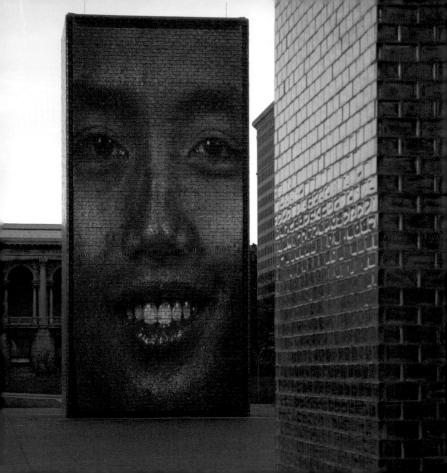

Rainbow Park Beach House

David Woodhouse Architects, LLC
Nayyar & Nayyar International (SE)

1999
3111 East 77th Street
South Shore

www.davidwoodhouse.com
www.chicagoparkdistrict.com

Fan-like sunshades made of translucent, corrugated fiberglass support the playful expression of the utilitarian building containing rest rooms, lifeguard station, and concession stand. The overall "beach aesthetic" is further enhanced by sand-colored concrete block and patterns of light and shadow.

Fächerartige Sonnenblenden aus lichtdurchlässigem, gewelltem Fiberglas unterstreichen die verspielte Wirkung des funktionellen Gebäudes mit Toiletten, Rettungsschwimmerstation und einer Verkaufsbude. Die „Strandästhetik" wird noch weiter verstärkt durch sandfarbene Betonblöcke und Muster aus Licht und Schatten.

Des pare-soleil semblables à des éventails en fibres de verre translucides et ondulées soulignent l'effet fantaisiste du bâtiment fonctionnel avec toilettes, une station de sauvetage aquatique et un point de vente. L' « esthétique de la plage » est encore plus renforcée par les blocs en béton de couleur sable et des motifs de lumière et d'ombre.

Las pantallas para protegerse del sol, con forma de abanico y fabricadas en vidrio de fibra translúcido y ondulado, subrayan el caprichoso efecto del edificio funcional con servicios, una cabina para los socorristas y una tienda. La estética "playera" se acentúa todavía más con los bloques de hormigón de color arena y el dibujo que crean las luces y las sombras.

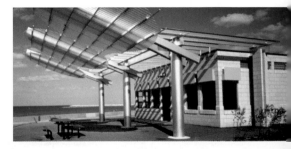

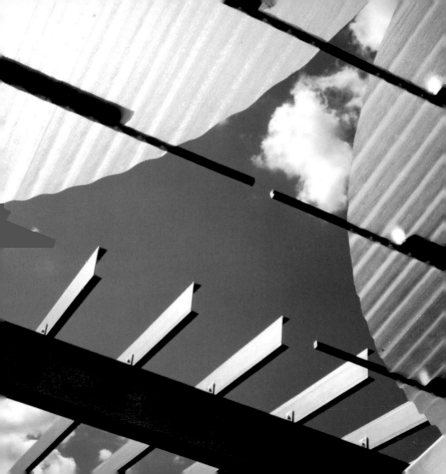

to stay . hotels

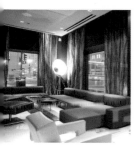
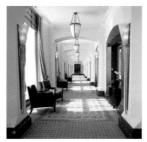
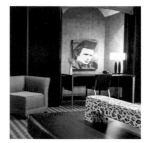
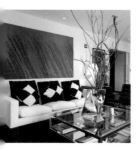
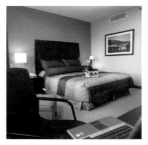
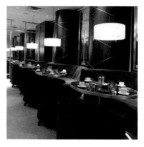

Sofitel Chicago Water Tower

Jean-Paul Viguier s.a. d'architecture
Teng

2002
20 East Chestnut Street
Gold Coast

www.viguier.com
www.teng.com
www.sofitel.com

The hotel with its angular, jutting profile has become a visual icon in the city's Gold Coast neighborhood. The sweeping glass curve of the lower level façade acts a scoop to passersby, directing them into the lobby space. Inside, the orthogonal grid of the exterior is juxtaposed with a variety of textures and jewel-toned fabrics.

Mit seinem eckigen, hervorstehenden Profil ist das Hotel zu einem visuellen Symbol im Stadtviertel Gold Coast geworden. Der ausladend geschwungene untere Teil der Glasfassade „schiebt" Passanten quasi in die Lobby hinein. Im Innern steht dem rechtwinkeligen Gitter der Fassade eine Vielzahl von Texturen und edelsteinfarbenen Stoffen gegenüber.

Avec son profil anguleux et en saillie, l'Hotel est devenu un symbole visuel du quartier Gold Coast. La partie inférieure en saillie de la façade en verre « pousse » quasiment les passants dans le hall principal. A l'intérieur, la grille rectangulaire de la façade fait face à un grand nombre de textures et de tissus en couleurs de pierres précieuses.

Su perfil anguloso y sobresaliente ha convertido el hotel en un símbolo visual del barrio Gold Coast. La forma saliente y curva de la parte inferior de la fachada de cristal "introduce" a los transeúntes en el vestíbulo. En el interior, la diversidad de texturas y de materiales del color de las piedras preciosas contrasta con la estructura rectangular de la fachada.

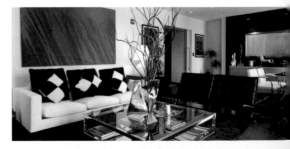

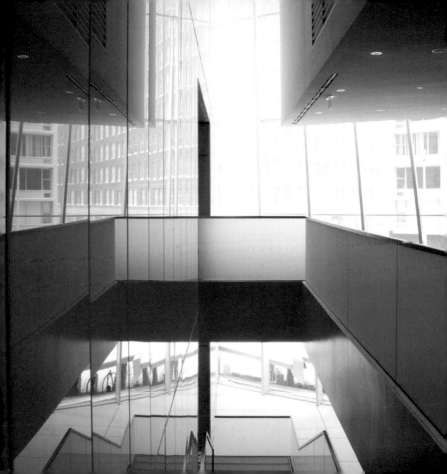

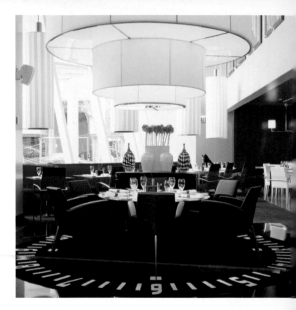

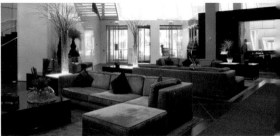

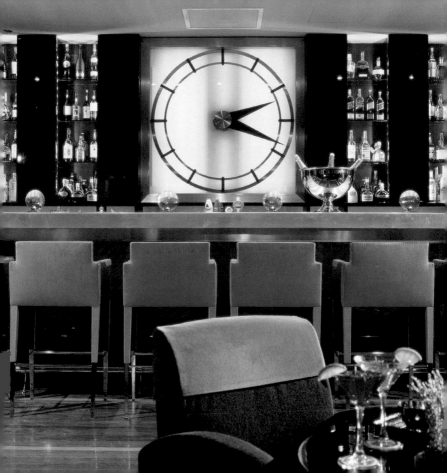

Park Hyatt Chicago

Lucien Lagrange Architects

2000
800 North Michigan Avenue
Gold Coast

www.llarch.com
www.parkchicago.hyatt.com

This tower provides 18 lower floors for the hotel and upper floors for residences. These programs are articulated on the exterior by different balcony profiles and variations in the setback. The wood-paneled interior is highlighted by classic lighting and bursts of accent color.

Die unteren 18 Stockwerke gehören zum Hotel, auf den oberen befinden sich Wohnungen. Die Nutzungsarten sind auch in der Außengestaltung zu erkennen, sowohl durch Unterschiede bei den Balkonprofilen als auch durch einen Rücksprung der Fassade. Das holzgetäfelte Interieur wird durch klassische Beleuchtung und Farbakzente aufgehellt.

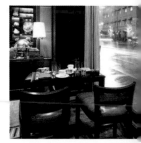

Les 18 étages inférieurs appartiennent à l'hôtel, les étages supérieurs hébergent des appartements. Les types d'utilisation se retrouvent aussi dans l'aménagement extérieur, autant par les balcons aux profils différents que par un petit retour de la façade. L'intérieur en boiseries est éclairci par un éclairage classique et des accents de couleurs.

Las primeras 18 plantas pertenecen al hotel. En los pisos superiores están las viviendas. Los usos del edificio se reflejan en su diseño exterior, tanto en los diferentes perfiles de los balcones como en el salto atrás en la fachada. El interior, revestido en madera, tiene una iluminación clásica y notas de color.

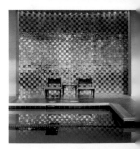

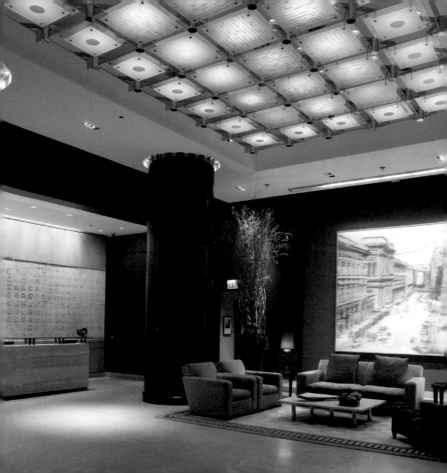

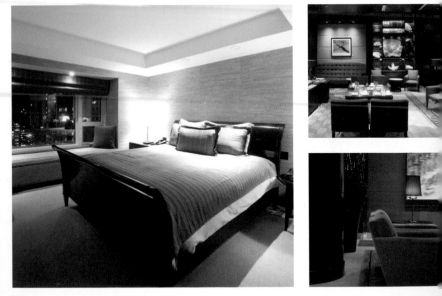

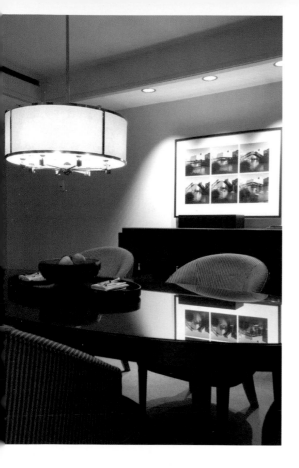

W City Center

Shopworks

2001
172 West Adams Street
Loop

www.shopworksdesign.com
www.starwoodhotels.com/whotels/
index.html

W City Center is in an older building in the commercial heart of Chicago. Stacks of glowing blocks mark the entrance to the grand two-story lobby with vaulted ceilings and dramatic uplighting; the effect is made complete with yards of velvet drapery and leather-upholstered chairs.

Das W City Center befindet sich in einem älteren Gebäude im Geschäftszentrum Chicagos. Leuchtsäulen flankieren den Eingang zur großen zweigeschossigen Lobby mit gewölbten Decken und dramatisch wirkenden Deckenflutern. Abgerundet wird der Effekt durch schwere Samtvorhänge und Ledersessel.

Le W City Center se trouve dans un ancien bâtiment du centre commercial de Chicago. L'entrée du grand hall de deux étages, avec ses plafonds en voûte et ses plafonniers produisant un effet dramatique, est flanquée de colonnes lumineuses. L'effet est parachevé par de lourds rideaux en velours et des fauteuils en cuir.

El W City Center ocupa un antiguo edificio en el centro financiero de Chicago. Las columnas iluminadas flanquean la entrada al gran vestíbulo de dos pisos, con techos abovedados y una espectacular iluminación. El resultado se completa con pesadas cortinas de terciopelo y sillones de cuero.

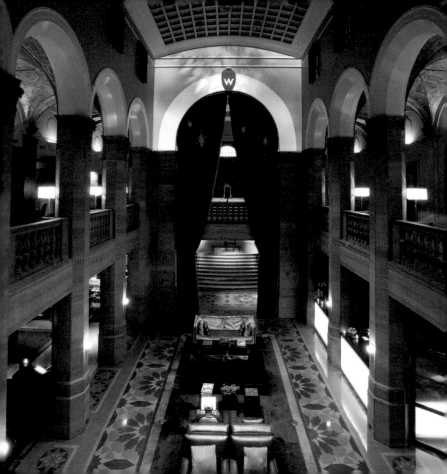

The Peninsula

Elkus Manfredi Architects Ltd.
Babey Moulton Jue & Booth

2001
108 East Superior Street
Near North

www.elkus-manfredi.com
www.bamo.com
chicago.peninsula.com

Chinese Foo Dogs, emblematic of the hotel chain's Asian property, guard the ground-level entrance. The main lobby hovers above high-end shops on Michigan Avenue; its high-ceilinged dining room, "The Lobby", is reminiscent of lavish hotel interiors from the 1930s and '40s.

Chinesische Foo-Hunde, Sinnbild der für den asiatischen Ursprung dieser Hotelkette, bewachen den Erdgeschosseingang. Die Hauptlobby befindet sich über exklusiven Geschäften auf der Michigan Avenue; der Speisesaal „The Lobby" mit der hohen Decke erinnert an die üppigen Hotelinterieurs aus den 1930er- und 1940er-Jahren.

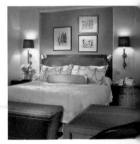

Les chiens Foo chinois, symboles de l'essor asiatique de cette chaîne d'hôtels sur le marché, surveillent l'entrée du rez-de-chaussée. Le hall principal est situé au-dessus de magasins exclusifs sur la Michigan Avenue; la salle à manger au plafond élevé, « The Lobby » , rappelle les intérieurs exubérants des hôtels des années 1930 et 1940.

Los perros foo chinos simbolizan el origen asiático de esta cadena hotelera y vigilan la entrada de la planta baja. El vestíbulo principal está situado encima de unas exclusivas tiendas de la Michigan Avenue; el comedor de techo alto, "The Lobby", evoca los ricos interiores de las décadas de 1930 y 1940.

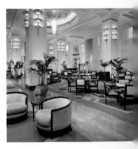

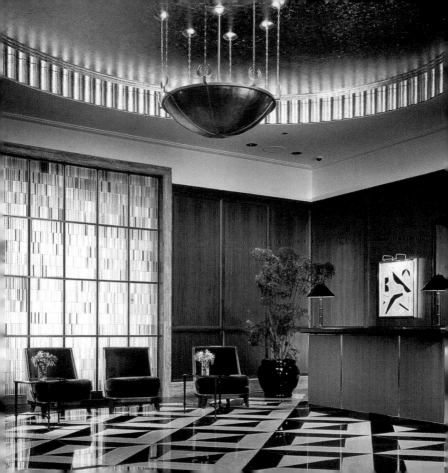

Hotel 71

Robert C. Vagnières Jr. & Associates,
Spectrum Design Architects & Engineers

2002
71 East Wacker Drive
North Loop

www.vagnieresarchitects.com
www.hotel71.com

The glass-and-steel building was designed in 1958 as a condominium building. Today, the sleek interior reflects its modernist lineage. The dark wood and varying reflectivity of materials in the lobby make the space a play of light and shadow.

Das Glas-und-Stahl-Bauwerk wurde 1958 als Wohngebäude entworfen. Heute spiegelt das glatte Interieur seine modernistische Abstammung wider. Das dunkle Holz und die unterschiedliche Reflexionskraft der Materialien in der Lobby lassen ein Spiel aus Licht und Schatten entstehen.

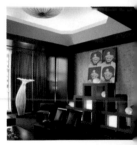

L'édifice en verre et en acier a été conçu en 1958 comme bâtiment d'habitation. Aujourd'hui, l'intérieur lisse reflète son origine moderniste. Le bois foncé et les différentes forces de réflexion des matériaux dans le hall créent un jeu d'ombre et de lumière.

Esta construcción de cristal y acero fue diseñada en 1958 como un edificio de viviendas. Hoy, su sencillo interior refleja su origen modernista. La madera oscura y las diferentes formas en que los materiales del vestíbulo reflejan la luz, crean un juego de luces y sombras.

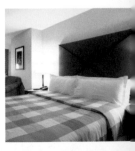

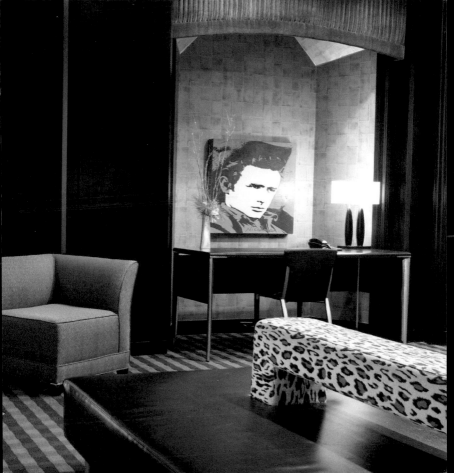

Hard Rock Hotel Chicago

Lucien Lagrange Architects
YabuPushelberg (interiors)

2004
230 North Michigan Avenue
North Loop

www.llarch.com
www.hardrockhotelchicago.com

The renovation of the Carbide and Carbon Building for the Hard Rock Hotel retained the original Art Deco exterior and gave it a facelift by replacing some of the original, 70-year-old terracotta tiles. The interior is rejuvenated with retro-inspired furniture and materials in black and purple.

Beim Umbau des Carbide and Carbon Building zum Hard Rock Hotel wurde die originale Art-déco-Fassade beibehalten und durch den Austausch einiger der 70 Jahre alten Terrakotta-Kacheln verschönert. Das Interieur wurde durch eine Einrichtung im Retro-Stil sowie durch Materialien in Schwarz und Violett verjüngt.

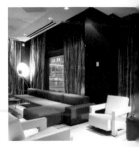

Lors de la transformation du Carbide and Carbon Building en Hard Rock Hotel, la façade art-déco d'origine a été conservée et embellie en procédant au remplacement de certains carreaux en terre cuite vieux de 70 ans. L'intérieur a été rajeuni par un aménagement en style rétro ainsi que des matériaux noirs et violets.

En la transformación del Carbide and Carbon Building en el Hard Rock Hotel, se conservó la original fachada art déco del edificio, aunque para embellecerla se cambiaron algunos de los azulejos de terracota, de 70 años de antigüedad. También se rejuveneció el interior empleando un mobiliario que combina el estilo retro con materiales de color negro y violeta.

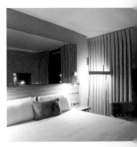

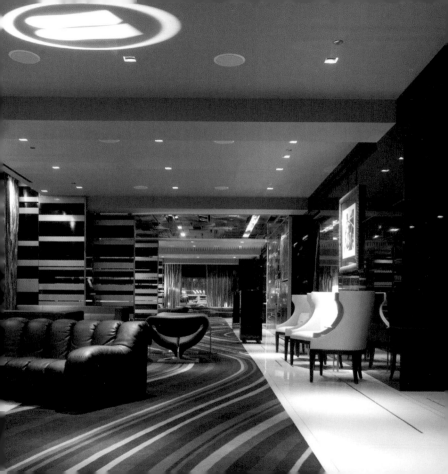

W Lakeshore

Shopworks

2001
644 North Lake Shore Drive
North Loop

www.shopworksdesign.com
www.starwoodhotels.com/whotels/
index.html

While the public spaces, including the rooftop lounge and lobby, are high-energy, high-profile spaces, the private rooms are more calm, restful spaces that use deep hues of red and gold with dark wood finishes to provide a spa-like atmosphere. Rooms in this hotel boast either lake or skyline views.

Während die öffentlichen Bereiche wie die Dachlounge und die Lobby äußerst energiegeladen und exklusiv sind, bieten die ruhigeren, in tiefen Rot- und Goldtönen und dunklem Holz gehaltenen Zimmer eine Atmosphäre wie in einem Wellnesscenter. Sämtliche Hotelzimmer dieses Hauses haben entweder Blick auf den See oder die Skyline.

Alors que les endroits publics, comme le bar-salon du toit et le hall, comportent beaucoup d'énergie et sont exclusifs, les pièces plus calmes réalisées dans des tons rouges et dorés foncés et en bois foncé offrent une atmosphère digne d'un centre wellness. Toutes les chambres d'hôtel de ce bâtiment ont vue soit sur le lac, soit sur la skyline.

Mientras que las zonas públicas, al igual que el salón en el último piso y el vestíbulo, son áreas exclusivas y muy cargadas de energía, las habitaciones, tranquilas, con revestimientos de madera y adornadas en profundos tonos rojos y dorados, ofrecen una atmósfera similar a la de un centro de wellness. Todas las habitaciones del hotel tienen vista al mar o al horizonte.

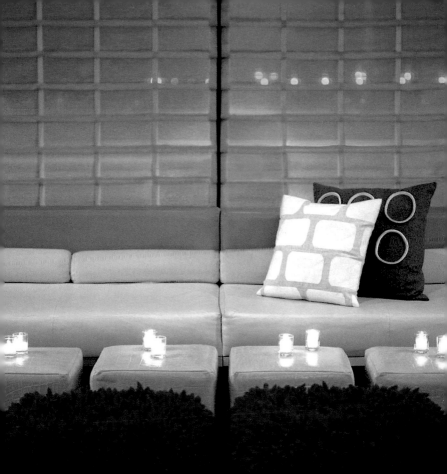

Amalfi Hotel

Rockwellgroup

2004
20 West Kinzie Street
River North

www.rockwellgroup.com
www.amalfihotelchicago.com

Amalfi Hotel stakes its claim at the intersection of Kinzie and Dearborn with stainless steel columns at the ground level that draw the eye up to the rounded tower on the corner. Inside, a small but sophisticated lobby is accented with cool shades of yellow, green, and blue.

Das Amalfi Hotel an der Kreuzung Kinzie und Dearborn Street lenkt den Blick des Betrachters durch die Edelstahlsäulen auf Bodenebene hinauf zu dem runden Turm an der Ecke. Die kleine aber mondäne Lobby im Innern wird durch kühle Gelb-, Grün- und Blautöne akzentuiert.

Dans le Amalfi Hotel, situé au croisement de Kinzie Street et de Dearborn Street, le regard de l'observateur est dirigé, à travers les colonnes en inox au niveau du sol, vers la tour ronde située au coin. A l'intérieur, le hall, petit mais mondain, est accentué par des tons froids de jaune, de vert et de bleu.

El Amalfi Hotel, situado en el cruce de las calles Kinzie y Dearborn, conduce la vista del observador a través de las columnas de acero desde el plano del suelo hacia la torre redonda, situada en la esquina. El pequeño pero elegante vestíbulo del interior se realza con los fríos colores amarillo, verde y azul.

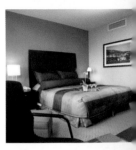

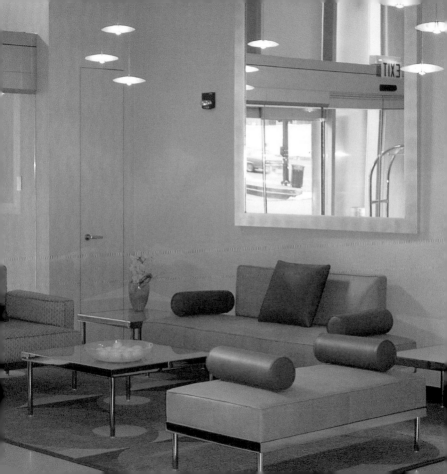

Le Meridien

Kay Lang, Kay Lang & Associates

2001
521 North Rush Street
River North

chicago.lemeridien.com

The large fifth-floor lobby is decorated with eclectic furnishings and artwork, while the adjoining hotel bar is a more cohesive, intimate space with dark wood, careful lighting, and geometric patterns.

Die große Lobby in der fünften Etage schmücken eklektische Einrichtungs- und Kunstgegenstände, während die angrenzende Hotelbar ein eher zusammenhängender, intimer Bereich mit dunklem Holz, dezenter Beleuchtung und geometrischen Mustern ist.

Le grand hall du cinquième étage est décoré d'objets d'aménagement et d'art éclectiques, alors que le bar attenant de l'hôtel est un lieu plutôt cohérent et intime avec du bois foncé, un éclairage décent et des motifs géométriques.

La composición ecléctica del mobiliario y de los objetos de arte adorna el gran vestíbulo, situado en la quinta planta, mientras que el contiguo bar del hotel es una zona más íntima donde predomina la madera oscura, una iluminación discreta y los dibujos geométricos.

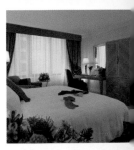

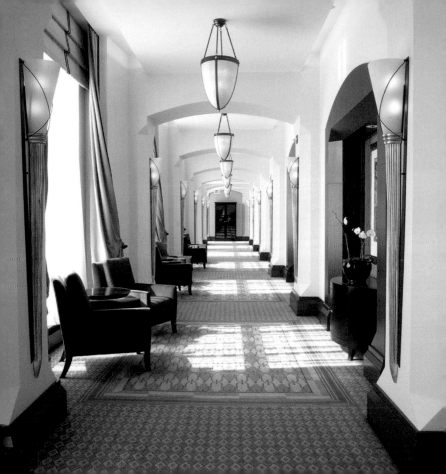

to go . eating
drinking
clubbing
wellness, beauty & sport

 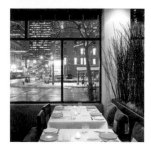

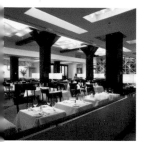 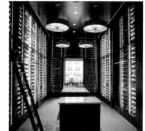 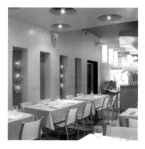

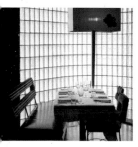 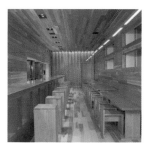 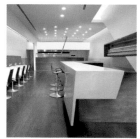

NoMI

Tony Chi and Associates

2000
800 North Michigan Avenue
Gold Coast

www.tonychi.com
www.nomirestaurant.com

Located on the seventh floor, the dining room of NoMI offers a spectacular view of Chicago's retail district, also known as the "Magnificent Mile". Supreme elegance and attention to detail is demonstrated through the choice of materials throughout the space, including Bolivian rosewood, Italian mosaic tiles, and English Broughton Moor slate.

Der im siebten Stock befindliche Speisesaal des NoMI bietet einen spektakulären Blick über Chicagos Einkaufsviertel, die „Magnificent Mile". Im gesamten Bereich zeigt sich in der Wahl der Materialien, wie bolivianisches Rosenholz, italienische Mosaikkacheln und Schiefer aus dem englischen Broughton Moor, Eleganz und Liebe zum Detail.

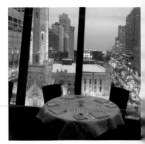

La salle à manger du NoMI se trouvant au septième étage offre une vue spectaculaire sur le quartier commerçant de Chicago, le « Magnificent Mile ». Partout, le choix des matériaux comme le bois de rose bolivien, les carreaux de mosaïque italiens et les ardoises du Broughton Moor anglais, l'élégance et l'amour du détail sont mis en avant.

El comedor del NoMI está situado en la séptima planta y ofrece una espectacular vista sobre el barrio comercial de la ciudad, el "Magnificent Mile". En todo el espacio se refleja la gran elegancia y el amor por los detalles a través de la elección de los materiales; palo de rosa boliviano, mosaicos italianos y pizarra inglesa de Broughton Moor.

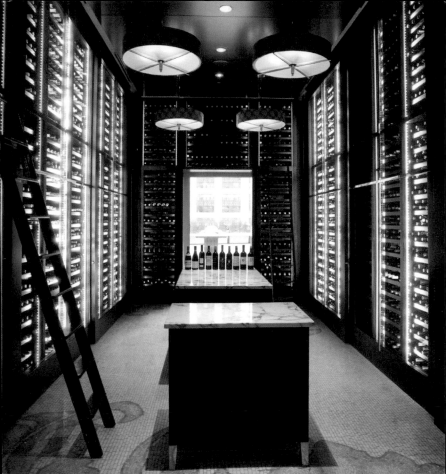

Zest Restaurant

Studio GAIA

2002
505 North Michigan Avenue
Loop

www.studiogaia.com
www.chicago.intercontinental.com

The minimalism is reinforced by the pale, monochromatic palette and virtual absence of decorative elements. The columns embedded with bands of glowing light add visual interest to the space. The dining room is split onto two levels, linked by a stone staircase and a curtain of light.

Der Minimalismus wird verstärkt durch eine blasse, monochromatische Farbpalette und die fast gänzliche Abwesenheit dekorativer Elemente. Die von Lichtbändern eingefassten Säulen erhöhen den optischen Reiz des Raumes. Der Speiseraum teilt sich auf zwei Ebenen auf, die durch eine Steintreppe und einen Lichtvorhang miteinander verbunden sind.

Le minimalisme est renforcé par une palette de couleurs pâles et monochromatiques et par l'absence quasiment complète d'éléments décoratifs. Les colonnes bordées de bandes de lumière augmentent le charme optique de la pièce. La salle à manger se divise en deux niveaux, ceux-ci étant reliés par un escalier en pierre et un rideau lumineux.

El minimalismo es reforzado por una gama de colores pálida y monocromática y por la ausencia casi completa de elementos decorativos. Las bandas de luz rodeando las columnas aumentan el encanto óptico del espacio. El comedor está dividido en dos planos unidos por una escalera de piedra y una cortina de luz.

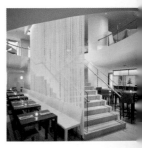

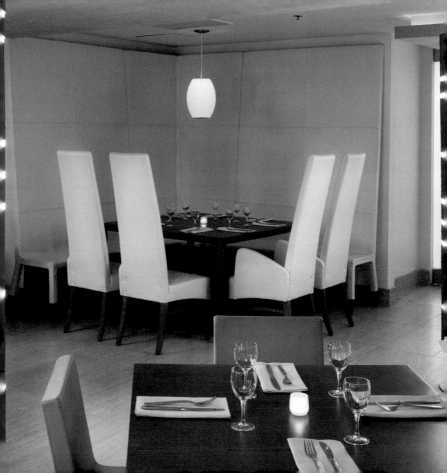

SushiSamba rio

Rockwellgroup

2003
504 North Wells Street
River North

www.rockwellgroup.com
www.sushisamba.com

The interior combines the sensual feel of the South American jungle with a more orthogonal, modern Asian aesthetic to reflect the hybrid of Japanese, Brazilian, and Peruvian cuisines. The restaurant's eye-catching seating bay in the center is surrounded by curtain of shiny metal pearls.

Das Interieur vereint den sinnlichen Eindruck des südamerikanischen Dschungels mit einer eher rechteckigen, modernen, asiatisch anmutenden Ästhetik und spiegelt so die Mischung aus japanischer, brasilianischer und peruanischer Cuisine wider. Blickfang des Restaurants bildet eine Sitzinsel im Zentrum, die von einem Vorhang aus glänzenden Metallperlen umgeben ist.

L'intérieur réunit l'impression sensuelle de la jungle sud-américaine et une esthétique plutôt rectangulaire, moderne, au charme asiatique et reflète ainsi le mélange des cuisines japonaise, brésilienne et péruvienne. Dans le restaurant, un îlot de places assises installé au centre accroche le regard, entourée d'un rideau de perles brillantes en métal.

El interior une la voluptuosidad de la jungla sudamericana con una estética asiática moderna y más bien angulosa, reflejando así la fusión de las cocinas japonesa, brasileña y peruana. El elemento más llamativo de este salón es la isleta de asientos del centro, que está rodeada por una cortina formada por brillantes bolas de metal.

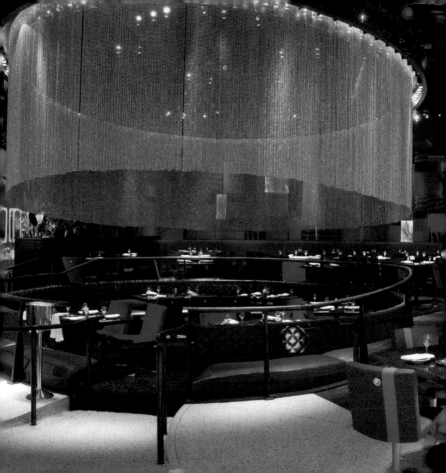

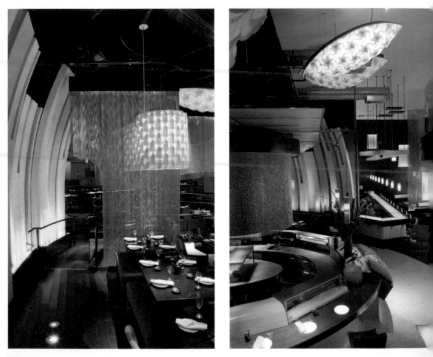

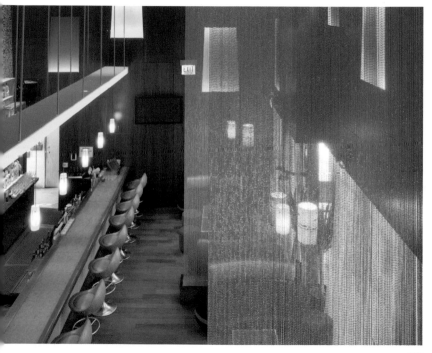

129

Tizi Melloul

Suhail Design Studio

1999
531 North Wells Street
River North

www.suhaildesign.com
www.tizimelloul.com

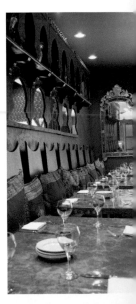

Hanging textiles and a rich material palette give the dining rooms a Moroccan flavor. Dense patterns in jewel tones complement the copper-topped tables, wooden fixtures, and leather seats throughout the space. The lounge is more subtle, with flowing lines reminiscent of a desert landscape.

Stoffdekorationen und eine reiche Farbpalette verleihen den Speiseräumen ein marokkanisches Flair. Dichte Muster in Edelstein-Farbtönen ergänzen die kupfernen Tische, hölzernen Leuchten und Lederstühle. Die Lounge ist subtiler angelegt mit fließenden Linien, die an eine Wüstenlandschaft erinnern.

Des décorations en tissu et une large palette de couleurs confèrent aux salles à manger un flair marocain. Des motifs denses dans des tons de gemmes viennent compléter les tables en cuivre, les lampes en bois et les chaises en cuir. Le bar-salon est aménagé avec subtilité avec des lignes fluides rappelant le paysage du désert.

La decoración con telas y una rica paleta de colores crea una atmósfera marroquí. Una profusión de dibujos en los colores de las piedras preciosas complementan el mobiliario formado por mesas de cobre, lámparas de madera y sillas de cuero. El salón presenta una decoración más sutil con líneas fluidas que evocan el paisaje del desierto.

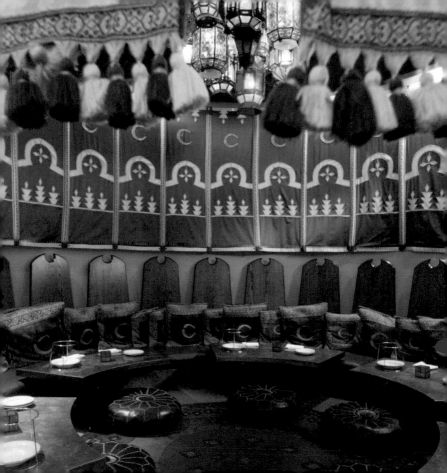

NAHA

Tom Nahabedian
NC Collaboration

2001
500 North Clark Street
River North

www.naha-chicago.com

Understated design is the setting for the Mediterranean-inspired American cuisine of NAHA. The dark walnut floor and chairs anchor the naturally lit space and ivory walls that are covered with mixed-media works by local artist Lora Fosberg.

Zurückhaltendes Design bildet den Hintergrund für die mediterran inspirierte amerikanische Küche des NAHA. Boden und Stühle aus dunklem Walnussholz bilden ein Gegengewicht zu dem natürlich erleuchteten Raum mit den elfenbeinfarbenen Wänden, an denen die Mixed-Media-Werke der Chicagoer Künstlerin Lora Fosberg zu sehen sind.

Un design discret crée l'arrière-plan de la cuisine américaine d'inspiration méditerranéenne du NAHA. Le sol et les chaises en bois foncé de noyer créent un contrepoids par rapport à la pièce naturellement éclairée aux murs couleur ivoire, sur lesquels sont exposées les œuvres mixed-media de l'artiste de Chicago Lora Fosberg.

Un diseño discreto sirve de trasfondo a la cocina americana con reminiscencias mediterráneas del NAHA. El suelo y las sillas son de madera oscura de nogal y contrastan con la iluminación natural del espacio y las paredes de color marfil, de donde cuelgan obras realizadas con técnica mixta de la artista de Chicago Lora Fosberg.

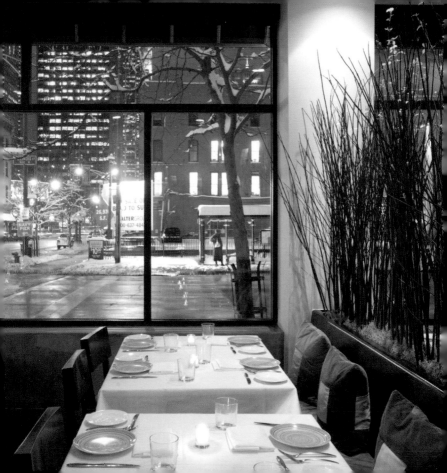

Sugar

Suhail Design Studio

2002
108 West Kinzie Street
River North

www.suhaildesign.com

The interior of this "dessert bar" is filled with textures and colors that invoke images of sweets. From the smooth, translucent, lozenge-like chairs and candy-wrapping tables to the multicolored beehive light fixtures and honeycomb walls, the design alone is enough to give you a sugar high.

Das Interieur dieser „Dessert-Bar" ist prallvoll mit Texturen und Farben, die an Süßigkeiten erinnern. Schon die glatten, durchsichtigen bonbonartigen Stühle und die Tische, die wie Bonbonpapier aussehen, die bunten Bienenstocklampen und Honigwabenwände reichen aus, um einen in Zuckerrausch zu versetzen.

L'intérieur de ce « bar-dessert » est plein à craquer de textures et de couleurs rappelant des friandises. Les chaises lisses et transparentes et les tables ressemblant à des papiers de bonbons, les lampes colorées imitant des ruches et les murs en rayons de miel suffisent à nous enivrer de sucre.

El interior de este "bar de postres" rebosa colorido y texturas que recrean los dulces. Las sillas lisas y transparentes y las mesas, que parecen de papel de caramelo, las lámparas con forma de colmenas y las paredes similares a colmenas, bastan para embriagar de azúcar al visitante.

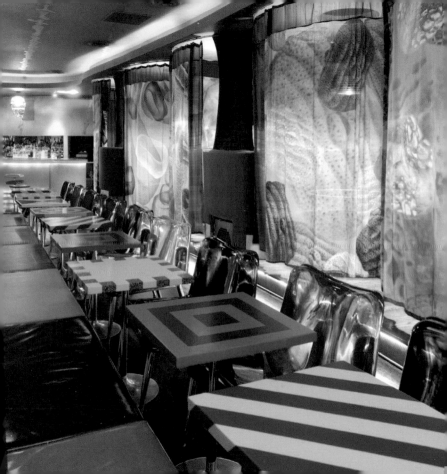

Japonais

Jeffrey Beers International

2004
600 West Chicago Avenue
River West

www.jeffreybeers.com
www.japonaischicago.com

The interior of Japonais uses refined elements like leather, mahogany, and velvet and juxtaposes them with concrete columns that serve as reminders of the restaurant's original industrial structure. The lighting fixtures, color combinations, and gridded elements throughout the space subtly invoke a Japanese aesthetic.

Im Interieur des Japonais bilden elegante Materialien wie Leder, Mahagoni und Samt einen Kontrast zu den Betonsäulen, die an das ehemals industrielle Aussehen des Restaurants erinnern. Die Lampen, Farbkombinationen und rechtwinkeligen Elemente verleihen dem Gesamtbild eine japanische Ästhetik.

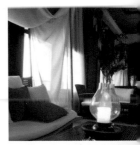

A l'intérieur du Japonais, des matériaux élégants comme le cuir, l'acajou et le velours créent un contraste par rapport aux colonnes en béton qui rappellent l'apparence autrefois industrielle du restaurant. Les lampes, les combinaisons de couleurs et les éléments rectangulaires confèrent à l'image d'ensemble une esthétique japonaise.

En el interior del Japonais, elegantes materiales como el cuero, la caoba y el terciopelo, contrastan con las columnas de hormigón que evocan el antiguo aspecto industrial del local. Las lámparas, las combinaciones de los colores y los elementos angulosos confieren al restaurante una estética japonesa.

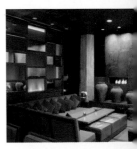

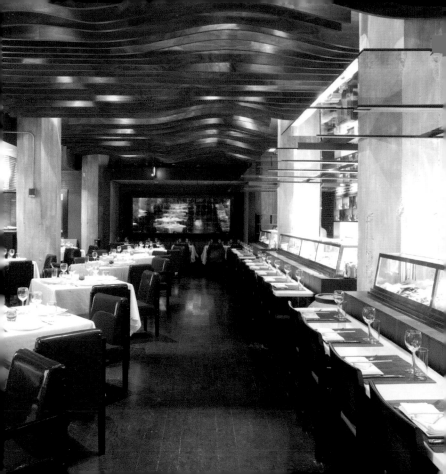

Opera

Jerry Kleiner

2003
1301 South Wabash Avenue
South Loop

www.opera-chicago.com

Here, a film storage facility was converted into high-ceilinged dining rooms and small, private booths for a Chinese restaurant. The entire space is an intense experience of riotous color and texture, from the whimsical furniture to the creative use of textiles that divide the space and filter light.

Hier wurde eine Filmlagerhalle zu einem chinesischen Restaurant mit hohen Speisesälen und kleinen Séparées umgewandelt. Das gesamte Gebäude vermittelt ein intensives Erlebnis durch das wilde Farb- und Texturspiel; von der skurrilen Einrichtung bis hin zum kreativen Einsatz von Textilien, die den Raum teilen und das Licht filtern.

Un entrepôt de films a ici été transformé en un restaurant chinois, avec des salles à manger aux murs très élevés et de petits salons particuliers. Tout le bâtiment procure une sensation intense grâce au jeu sauvage des couleurs et des textures, de l'aménagement cocasse à l'utilisation créative de textiles séparant la pièce et filtrant la lumière.

Aquí, un almacén de películas ha sido transformado en un restaurante chino con comedores de techos altos y un reservado. El conjunto del edificio transmite una intensa sensación por el fantástico juego entre los colores y las texturas; desde el extravagante mobiliario hasta el creativo empleo de telas, que dividen el espacio y filtran la luz.

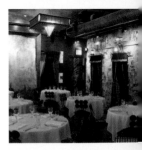

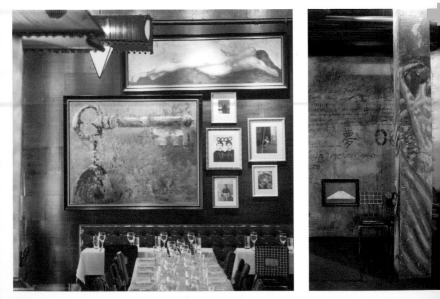

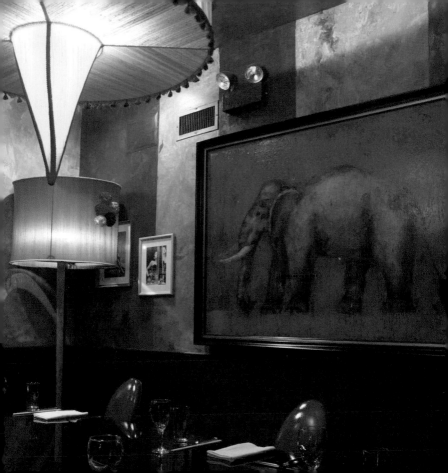

Follia

Melissa Abate, Bruno Abate

2002
953 West Fulton Market
West Loop

www.folliachicago.com

The front windows feature rotating displays of art and fashion design, advertising the restaurant's Milanese cuisine and Italian high-style atmosphere. The patch of bright green Astroturf hanging on the wall sets off the white linens and pale green tile of the central bar.

In den Frontfenstern sind rotierende Kunst- und Modedesign-Displays zu sehen, mit denen für die Mailänder Küche und exklusive italienische Atmosphäre des Restaurants geworben wird. Der leuchtend grüne Kunstrasen an der Wand bildet einen Kontrast zu den weißen Tischtüchern und blassgrünen Fliesen der zentralen Bar.

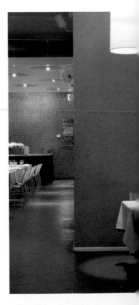

Des présentoirs d'art et de design de mode tournants sont visibles dans les fenêtres de la façade, faisant de la publicité pour la cuisine milanaise et l'atmosphère italienne exclusive du restaurant. Au mur, la pelouse artificielle en vert brillant crée un contraste par rapport aux nappes en blanc et aux carreaux verts pâles du bar central.

En las ventanas frontales pueden verse imágenes de arte y de diseño de moda girando, con las que se quiere hacer publicidad de la cocina milanesa y de la exclusiva atmósfera italiana del restaurante. El verde brillante del césped artificial de las paredes, contrasta con el blanco de los manteles y los azulejos en verde pálido del bar.

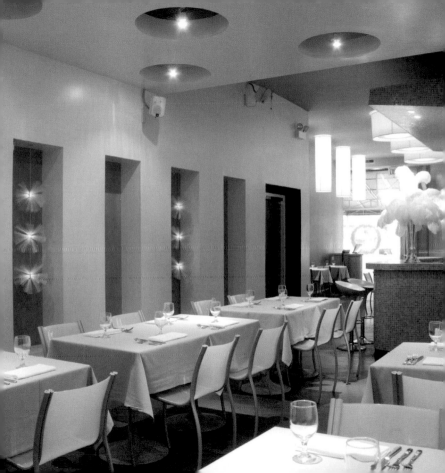

one sixtyblue

Adam T. Tihany

1998
160 North Loomis Street
West Loop

www.tihanydesign.com
www.onesixtyblue.com

While the tall wooden columns punctuating the interior pay homage to one sixtyblue's industrial beginnings, the warm, subtle lighting and lustrous materials make the space intimate and classy.

Während die hohen Holzsäulen im Interieur eine Hommage an die industriellen Anfänge sind, verleihen die warme, subtile Beleuchtung und die schimmernden Materialien diesem Ort Intimität und Stil.

Alors que les grandes colonnes en bois de l'intérieur constituent un hommage aux débuts industriels, l'éclairage chaud et subtil ainsi que les matériaux scintillants confèrent à ce lieu intimité et style.

Mientras que las columnas de madera del interior rinden homenaje a los orígenes industriales, el espacio adquiere una atmósfera íntima y llena de estilo a través de la cálida y sutil iluminación y los brillantes materiales.

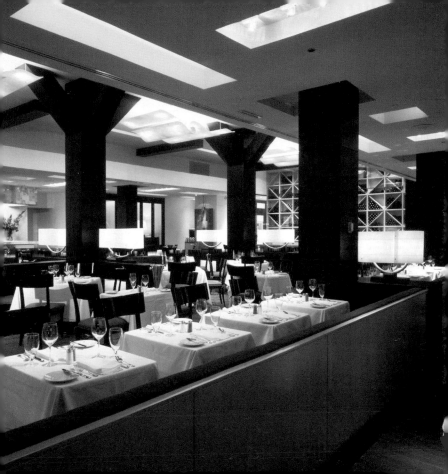

avec

Thomas Schlesser

2003
615 West Randolph Street
West Loop

www.avecrestaurant.com

The restaurant reveals a similarly minimalist aesthetic as the Blackbird, but it has a touch more warmth. The interior of this wine bar is meant to reflect the materials used in winemaking; the designer incorporates oak floors and walls as well as vineyard earth, cork, and bottle glass into the design.

Das Restaurant weist eine ähnlich minimalistische Ästhetik wie das Blackbird auf, besitzt jedoch einen Hauch mehr Wärme. Das Interieur dieser Weinbar soll die bei der Weinherstellung verwendeten Materialien widerspiegeln; dazu verwendet der Designer Eichenfußböden und -wände sowie Weinbergerde, Kork und Flaschenglas.

Le restaurant présente une esthétique minimaliste semblable à celle du Blackbird, mais il est toutefois un peu plus chaleureux. L'intérieur de ce bar à vin est censé refléter les matériaux utilisés lors de la fabrication du vin ; pour cela, le designer a eu recours à des sols et à des murs en chêne ainsi qu'à de la terre de vigne, du liège et du verre de bouteille.

El restaurante tiene una estética minimalista similar a la del Blackbird, aunque con una nota cálida. El interior de este bar especializado en vinos es un reflejo de los materiales empleados en la elaboración de este caldo, y para su decoración, el diseñador ha empleado suelos y paredes de roble, tierra de viñedos, corcho y cristal de botella.

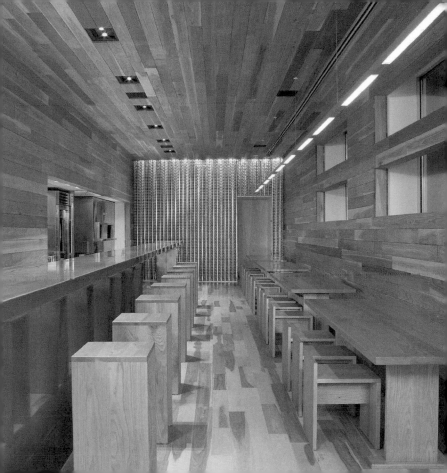

Blackbird

Thomas Schlesser

1997
619 West Randolph Street
West Loop

www.blackbirdrestaurant.com

The essential modernist elements of pure geometry and color are demonstrated in the design. The brilliant white walls and tabletops provide a contrast to the sleek black chairs and wooden floor, but in a way that puts the food on center stage as the primary sensory stimulation.

Das Design demonstriert reine Geometrie und Farbe als die wesentlichen Elemente des Modernismus. Die leuchtend weißen Wände und Tische stellen einen Kontrast zu den glatten schwarzen Stühlen und dem Holzfußboden dar; der Gesamteindruck rückt jedoch das Essen als primäres Erlebnis in den Mittelpunkt.

Le design démontre que la géométrie pure et les couleurs pures sont des éléments essentiels du modernisme. Les murs et les tables en blanc brillant créent un contraste par rapport aux chaises noires lisses et au sol en bois ; l'impression d'ensemble met cependant en avant le repas comme une expérience primaire.

El diseño demuestra que la geometría y los colores puros son los elementos centrales del modernismo. Las brillantes paredes y las mesas blancas contrastan con el negro de las sillas y del suelo de madera; la impresión general, sin embargo, se desliza a un segundo plano para realzar la comida como experiencia primaria.

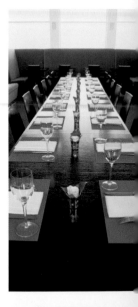

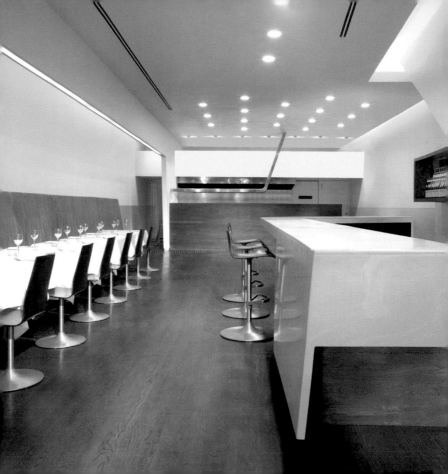

MOD

Suhail Design Studio

2000
1520 North Damen Avenue
Wicker Park

www.suhaildesign.com
www.modrestaurant.net

This bar is a sleek, brightly lit space with a futuristic feel. The contrasting opacities of the furnishings—reflective metal, opaque plastic, and translucent panels—give the space a colorful depth. A circle motif is repeated throughout the design.

Diese elegante, hell erleuchtete Bar besitzt eine futuristische Atmosphäre. Die unterschiedliche Lichtdurchlässigkeit der Einrichtung – reflektierendes Metall, lichtundurchlässiger Kunststoff und durchsichtige Täfelung – verleihen dem Ort eine farbenfrohe Tiefe. Der Kreis als Leitmotiv zieht sich durch das gesamte Design.

Ce bar élégant et brillamment éclairé possède une atmosphère futuriste. Les différents types de translucidité de l'aménagement – métal réfléchissant, PVC opaque et lambris transparents – confèrent au lieu une intensité bigarrée. Le leitmotiv du cercle s'étend sur la totalité du design.

Este bar elegante y de clara iluminación posee una atmósfera futurista. Los diferentes efectos de la luz sobre los materiales de la decoración, metal reflectante, plástico opaco y paneles transparentes, dotan al local de una intensidad colorista. El círculo es el motivo dominante y está presente en todo el diseño.

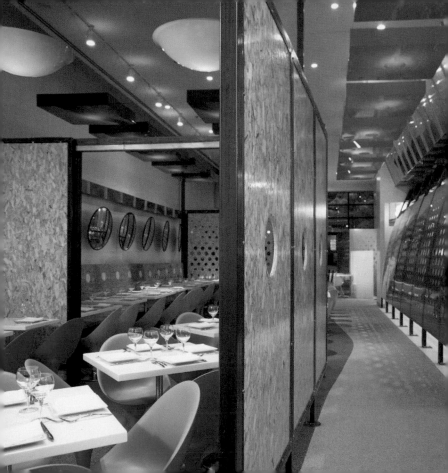

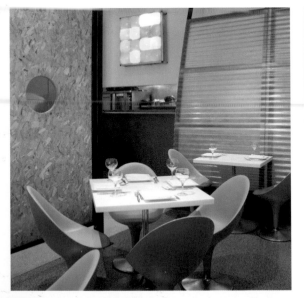

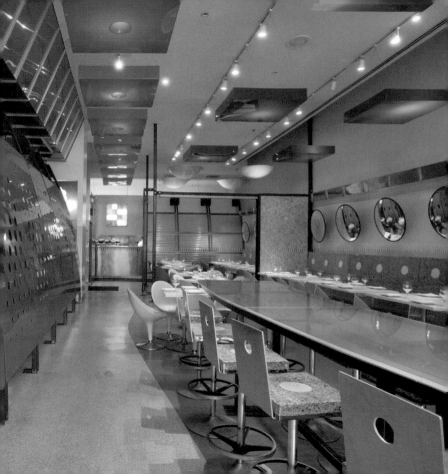

Urban Oasis

McBride Kelley Baurer Architects

2003
939 West North Avenue
Lincoln Park

www.mkbdesign.net
www.urbanoasis.biz

The interior is curvilinear and is reminiscent of the natural curves of the human body. With soft lighting and the use of warm materials such as Indian Slate, the spa provides a sanctuary for clients. The reception is separated from the treatment rooms with a sandblasted glass wall.

Das Interieur erinnert an die natürlichen Kurven des menschlichen Körpers. Weiche Beleuchtung und warme Materialien wie indischer Schiefer machen das Wellnesscenter zu einem Zufluchtsort. Der Empfang ist durch eine Wand aus sandgestrahltem Glas von den Behandlungsräumen getrennt.

L'intérieur rappelle les courbes naturelles du corps humain. Un éclairage doux et des matériaux chauds comme l'ardoise indienne font du centre wellness un lieu de refuge. La réception est séparée des salles de soins à l'aide d'un mur en verre sablé.

El interior evoca las curvas naturales del cuerpo humano. La suave iluminación y los cálidos materiales empleados, como la pizarra india, convierten este centro de wellness en un refugio. La recepción está separada de las salas de los tratamientos por una mampara de cristal tratada con chorro de arena.

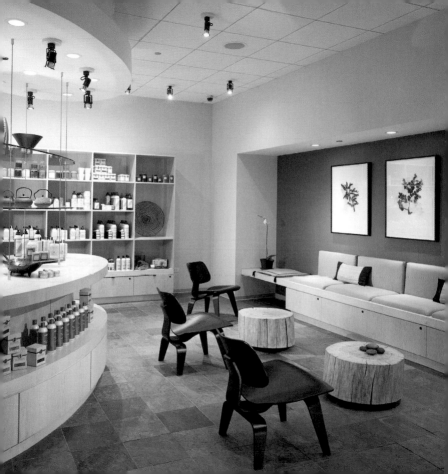

Michael & Michael

Ellen M. Mills
Michael Crowley
Michael Jacobson

2003
365 West Chicago Avenue
River North

www.michaelandmichael.com

This 1895 building is both a contemporary hair salon and showplace for the arts. Cutting stations are generously set apart from one another to emphasize personal attention to clients and a cleared out pathway runs through the middle of the room, providing a catwalk for shows.

Dieses Gebäude aus dem Jahre 1895 ist sowohl zeitgenössischer Frisörsalon als auch Schauplatz der Künste. Die relativ weit von einander entfernten Frisierstühle unterstreichen, welche Aufmerksamkeit dem einzelnen Kunden gewidmet wird. In der Mitte des Raumes verläuft ein Pfad, der gleichzeitig als Catwalk für Shows dient.

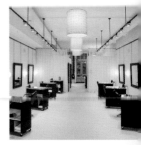

Ce bâtiment construit en 1895 fait office à la fois de salon de coiffure contemporain et de lieu d'exposition artistique. Les chaises de coiffure relativement éloignées les unes des autres soulignent l'attention que l'on accorde à chaque client. Un chemin traverse le milieu de la pièce et sert également de catwalk pour les défilés.

Este edificio es, además de una peluquería moderna, un escenario para las creaciones artísticas. Los sillones de la peluquería están bastantes separados entre sí, lo que subraya la atención personalizada que se le quiere dar al cliente. En el centro del espacio hay una pista que se utiliza a modo de pasarela durante los desfiles.

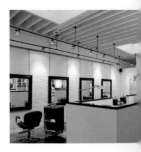

New Stadium at Soldier Field

Wood + Zapata Architecture
Lohan Caprile Goettsch Architects
Thornton Tomasetti Engineers (SE)

2003
1410 South Museum Campus Drive
South Loop

www.wood-zapata.com
www.lohan.com
www.soldierfield.net

Sprawling 1,800,000 ft² of space, this stadium is a commentary on the energy of competitive sports. Scoreboards are cantilevered and linked spatially throughout to maximize audience attention, while keeping the endzone structurally low to pay homage to the skyline.

Die rund 167.000 m² dieses Stadions sollen die Energie des Wettkampfsports verdeutlichen. Die Anzeigetafeln sind so angebracht, dass sie für jeden Zuschauer, wo immer er sich befindet, einsehbar sind, während ein Ende des Stadions zu Ehren der Skyline relativ niedrig gehalten wurde.

La surface approximative de 167 000 m² de ce stade est censée symboliser l'énergie du sport de compétition. Les tableaux d'affichage sont installés de façon à ce que chaque spectateur puisse les voir, quel que soit l'endroit où il se trouve, alors que la hauteur de l'une des extrémités est relativement peu élevée, rendant ainsi hommage à la skyline.

Los aproximadamente 167.000 m² de este estadio quieren ilustrar la energía del deporte de competición. Las pantallas de los resultados están dispuestas de tal forma que son visibles para todos los espectadores desde cualquier ángulo. Uno de los extremos tiene menos altura para permitir la vista del horizonte.

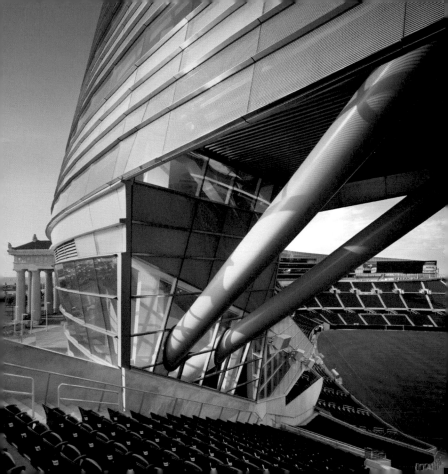

Ruby Room

Kate Leydon

2003
1743 West Division Street
Wicker Park

www.rubyroom.com

Utilizing feng shui, this boutique spa offers a home like experience with its cream brick walls and fireplace. Imperial red colored doors adorned with a winged archway lead to the Healing Sanctuary, where private rooms are enclosed with ceiling to floor silk taffeta curtains.

Cette spa individuelle s'appuie sur le Feng-Shui et permet, avec ses murs en brique couleur crème et sa cheminée, que les clients se sentent chez eux. Les portes rouges pourpres, ornées d'un arc avec battant, conduisent au Healing Sanctuary. On trouve ici des pièces extrêmement calmes, encadrées de rideaux en taffetas aussi hauts que la pièce.

Dieses individuelle Spa setzt auf Feng-Shui und sorgt mit cremefarbenen Backsteinwänden und Kamin dafür, dass sich die Kunden wie zu Hause fühlen. Türen in Purpurrot, verziert mit einem geflügelten Torbogen, führen zum Healing Sanctuary. Hier befinden sich Räume, in denen man ungestört ist und die eingefasst sind von raumhohen Vorhängen aus Seidentaft.

Este spa individual apuesta por el Feng Shui y sus paredes, de color crema, y la chimenea, hacen que los clientes se sientan como en casa. Las puertas de color púrpura, adornadas con un arco alado, conducen al Healing Sanctuary. Aquí se encuentran los espacios para el descanso, rodeados por cortinas de tafetán de seda que van desde el techo hasta el suelo.

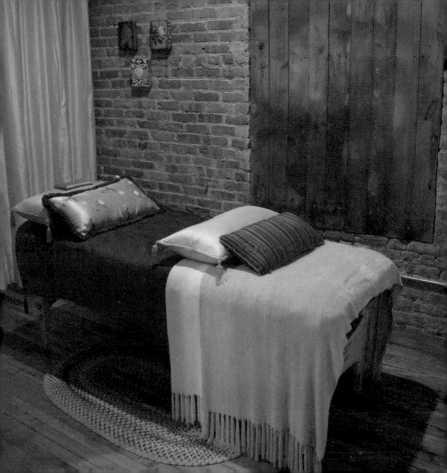

to shop . mall
retail
showrooms

 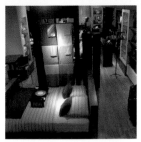

 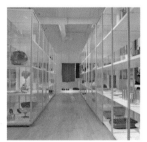 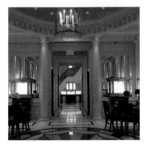

Belly Dance Maternity

Scrafano Architects

2002
1647 North Damen Avenue
Bucktown

www.bellydancematernity.com

Custom built plywood boxes showcase the maternity wear in the front of the room. With a comfortable shopping experience in mind, a lounge was created adjacent to the fitting rooms.

In speziell angefertigten Sperrholzkästen vor dem Raum ist die Umstandskleidung ausgestellt. Damit die Gemütlichkeit beim Einkaufen nicht zu kurz kommt, wurde neben den Ankleidekabinen eine Lounge eingerichtet.

La collection grossesse est exposée dans des caissons en contreplaqué spécialement conçus et placés devant la pièce. Pour ne pas perdre le caractère de bien-être en faisant ses courses, un bar-salon a été aménagé près des cabines d'essayage.

La ropa para embarazadas está situada al comienzo del local en grandes cajones de madera contrachapada fabricados especialmente para este fin. Para que comprar sea algo cómodo, se ha dispuesto un salón al lado de los probadores.

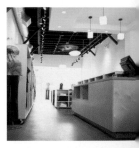

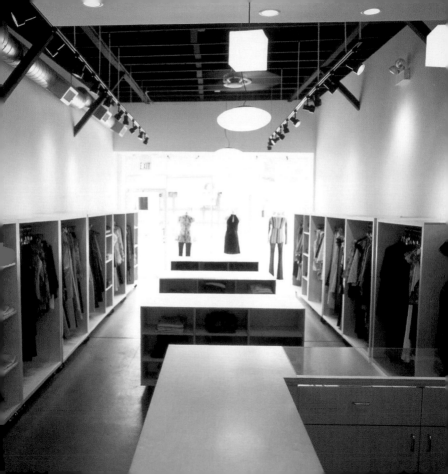

Hejfina

Heiji Choy
Seem Studio

2004
1529 North Milwaukee Avenue
Bucktown

www.seemstudio.com
www.hejfina.com

Stainless steel racks line each side of this elongated boutique that conglomerates fashion, home design, and architecture. Plastic display light boxes drift through the center of the space, providing space for shoes and accessories. Canvas painted artwork from the Clamdiggin' artists provide splashes of color on the white walls.

Edelstahlregale verlaufen zu beiden Seiten dieser lang gestreckten Boutique, die Mode, Home-Design und Architektur miteinander verbindet. In der Mitte des Raumes bieten erleuchtete Plastik-Displays Platz für Schuhe und Accessoires. Gemälde der Künstlergruppe Clamdiggin' bilden Farbtupfer auf den weißen Wänden.

Des étagères en inox longent les deux côtés de cette boutique construite en longueur et qui allie mode, home-design et architecture. Au milieu de la pièce, des présentoirs illuminés en plastique offrent de la place pour les chaussures et les accessoires. Les peintures du groupe artistique Clamdiggin' apportent des touches de couleurs sur les murs blancs.

Estanterías de acero recorren los dos lados de esta tienda de ropa, de planta alargada y donde la moda se une con el interiorismo y la arquitectura. En el centro del local, los expositores de plástico iluminados ofrecen espacio para los zapatos y los accesorios. Las pinturas del grupo de artistas Clamdiggin' son puntos de color sobre las paredes blancas.

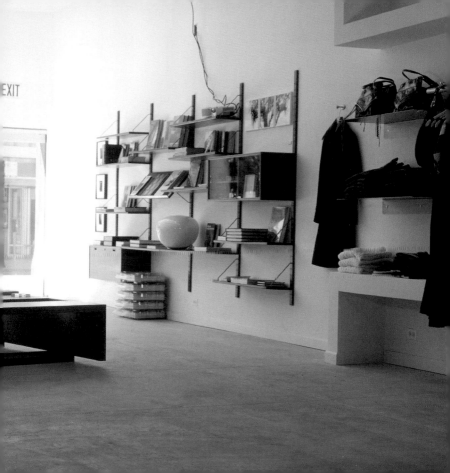

Stitch

Pamela Hewett

1999
1723 North Damen Avenue
Bucktown

www.stitchchicago.com

With lofty ceilings and skylights, this home design and accessories boutique maximizes its space with modular shaped cases and mahogany shelves. Pale blue walls and ample natural lighting create a clean, modern look.

Mit hohen Decken und Oberlichtern sowie Schränken im Baukastenprinzip und Mahagoniregalen bietet diese Boutique für Home-Design und Accessoires reichlich Platz. Blassblaue Wände und viel natürliches Licht sorgen für einen sauberen, modernen Look.

Avec de hauts plafonds et des impostes, ainsi que des armoires modulaires et des étagères en acajou, cette boutique de home-design et d'accessoires offre de la place en grande quantité. Les murs bleu pâle et une lumière naturelle abondante garantissent une apparence caractérisée par la propreté et le modernisme.

Los elevados techos, los tragaluces, los armarios modulares y las estanterías en caoba de esta tienda, ofrecen suficiente espacio para los elementos de diseño para la casa y los accesorios. Las paredes de color azul pálido y la iluminación natural confieren al espacio un aspecto claro y moderno.

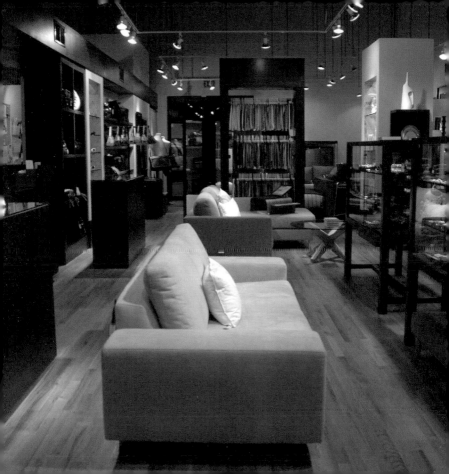

Apple Store

Bohlin Cywinski Jackson

2003
679 North Michigan Avenue
Gold Coast

www.bcj.com
www.apple.com

This brightly lit space creates a user-friendly environment for savvy techies. Apple products are displayed throughout the first level along the walls and long tables. Centrally located in the store is a glass stairway that leads directly to the workshop theater and the Genius Bar.

Dieses hell erleuchtete Gebäude bietet Computerfreaks eine benutzerfreundliche Umgebung. Im Erdgeschoss findet man entlang der Wände und der langen Tische Apple-Produkte, und in der Mitte des Raumes führt eine gläserne Treppe direkt zum Veranstaltungsraum und der Genius Bar.

Ce bâtiment brillamment éclairé offre aux mordus de l'informatique un environnement adapté aux visiteurs. Au rez-de-chaussée, on trouve des produits Apple le long des murs et sur de longues tables, et un escalier en verre situé au centre de la pièce mène directement à la salle de conférences et au Genius Bar.

Este edificio de iluminación clara ofrece un entorno de fácil manejo para los entusiastas de los ordenadores. En la planta baja hay productos de Apple expuestos a lo largo de las paredes y sobre las largas mesas y, en el centro del espacio, se levanta una escalera transparente que conduce a la sala de actos y al bar Genius.

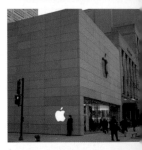

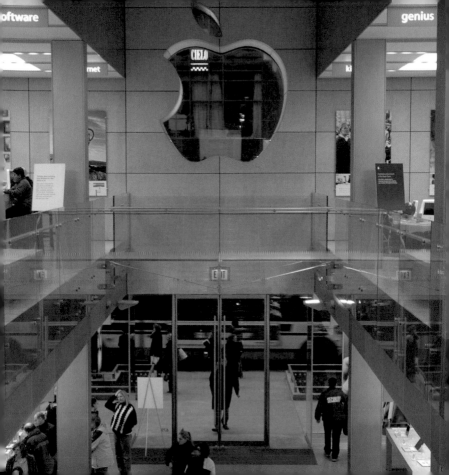

Graff Diamonds

Lawrence Graff

2004
103 East Oak Street
Gold Coast

www.graffdiamonds.com

The newest addition to this jewelry store boasts 35-foot vaulted ceilings with an impressive winding staircase. To showcase Graff's collection, numerous vitrines were created for the shop. No detail was spared, from the gilded ceiling to the Italian marble floors.

Die neueste Zweigstelle dieses Juweliergeschäfts wartet mit 10 m hohen gewölbten Decken und einer beeindruckenden Wendeltreppe auf. Um die Graff-Kollektion richtig zur Schau zu stellen, wurden zahllose Vitrinen für das Geschäft gebaut. Es wurde Wert auf Details gelegt, von einer vergoldeten Decke bis hin zu Böden aus italienischem Marmor.

La filiale la plus récente de cette joaillerie présente des plafonds en voûte de 10 m de haut et un impressionnant escalier en colimaçon. Afin de présenter correctement la collection Graff, d'innombrables vitrines ont été construites pour le magasin. Les concepteurs ont apporté beaucoup de soin au détail, du plafond doré aux sols en marbre italien.

La nueva sucursal de esta joyería tiene en su interior unos techos abovedados de 10 m de altura y una impresionante escalera de caracol. Para exhibir correctamente la colección Graff, se han fabricado innumerables vitrinas para la tienda. En el diseño se ha otorgado una gran importancia a los detalles, desde el techo dorado hasta los suelos de mármol italiano.

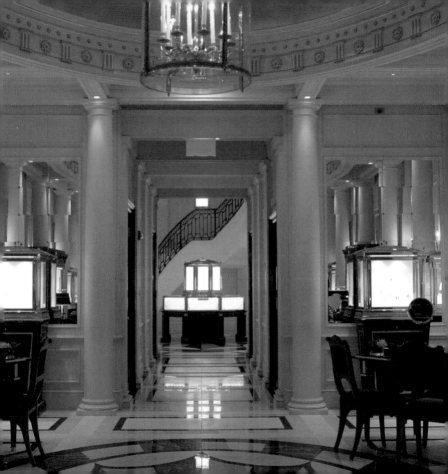

Ikram

Mario Aranda & Josh Goldman

2001
873 North Rush Street
Gold Coast

www.ikramonline.com

Hand blown glass objects drip from the ceilings creating a warm, inviting environment to this upscale women's boutique. Gold and red painted walls are juxtaposed against the dark wood floors and custom built fixtures. No detail is spared, from the Rubin Toledo mannequins to fitting room hangers made from water carriers.

Mundgeblasene Glasobjekte „tropfen" von der Decke und lassen diese Damenboutique warm und einladend wirken. Wände in Gold und Rot bilden einen Kontrast zu den dunklen Holzböden und speziell angefertigten Leuchten. Es wurde Wert auf Details gelegt, von den Rubin-Toledo-Schaufensterpuppen bis hin zu den aus Wasserkrügen gefertigten Kleiderhaken.

Des objets en verre soufflés à la bouche « gouttent » du plafond et donnent un effet chaleureux et attrayant à cette boutique pour femmes. Les murs or et rouges créent un contraste par rapport aux sols en bois sombre et aux lampes spécialement conçues. Les créateurs ont accordé de l'importance aux détails, des mannequins Rubin Toledo aux portemanteaux en cruches d'eau.

Los objetos de cristal soplados "gotean" del techo de esta boutique de señoras haciendo del espacio un lugar cálido y atractivo. Las paredes en oro y rojo, contrastan con los oscuros suelos de madera y las lámparas, de fabricación especial. Los detalles fueron importantes en el diseño, desde los maniquís de Rubin Toledo hasta los ganchos para colgar la ropa, hechos de cántaros.

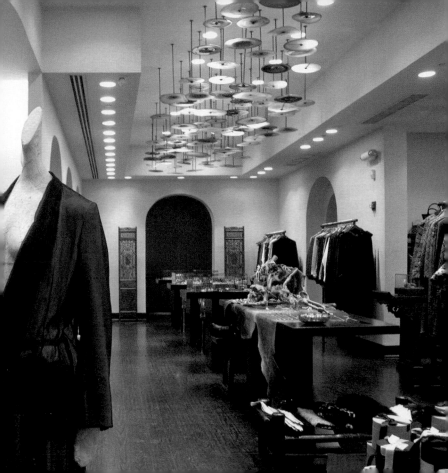

Luminaire

pappageorge/haymes Ltd.

1995
301 West Superior Street
River North

www.pappageorgehaymes.com
www.luminaire.com

With three levels of lofty showroom space, Nasir and Nargis Kassamali are able to bring the world's most innovative contemporary furnishings together in one location. An open layout, wide steel staircases, and minimalist interior allow the merchandise to be the focal point.

In hohen Showräumen auf drei Ebenen vereinen Nasir und Nargis Kassamali die innovativsten zeitgenössischen Einrichtungsgegenstände der Welt. Eine offene Aufteilung, breite Stahltreppen und ein minimalistisches Interieur rücken die Ware in den Mittelpunkt.

Dans les grandes pièces d'exposition s'étendant sur trois niveaux, Nasir et Nargis Kassamali réunissent les objets d'aménagement contemporains les plus innovants du monde. Une répartition ouverte, de larges escaliers d'acier et un intérieur minimaliste mettent en avant la marchandise.

En las salas de exposición y ventas, de techos altos y distribuidas en tres plantas, Nasir y Nargis Kassamali fusionan los elementos de mobiliario más innovadores y modernos del mundo. La división abierta, la amplia escalera de acero y un interior minimalista colocan los productos en el primer plano.

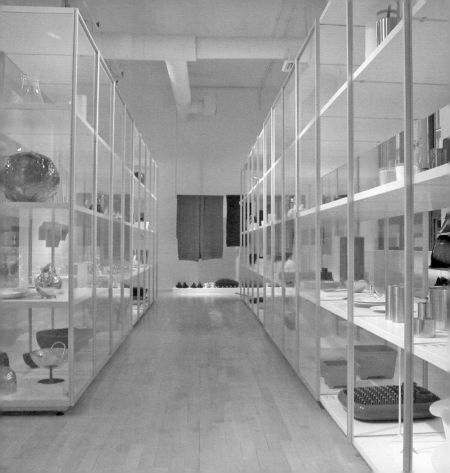

Jake

Lance Lawson
Jim Wetzel

2004
3740 North Southport Avenue
West Lakeview

www.shopjake.com

With mid 20th century furnishings, such as a vintage church pendant lamp, or the leather Eames chairs, this boutique fuses a historical with a modern concept. A space-age Sputnik lamp and cowhide rug are reminiscent of Easy Rider.

Mit ihrer Einrichtung aus der Mitte des letzten Jahrhunderts, wie der charakteristischen Kirchenhängeleuchte oder den Eames-Ledersessel verbindet diese Boutique Historisches mit einem modernen Konzept. Eine Sputnik-Lampe aus dem Weltraumzeitalter sowie ein Kuhfell-Teppich erinnern an Easy Rider.

Avec son aménagement datant du milieu du siècle dernier, comme le lustre d'église caractéristique ou les fauteuils Eames en cuir, cette boutique allie des éléments historiques au concept moderne. Une lampe Spoutnik, symbole de l'ère de l'espace, ainsi qu'un tapis en peau de vache rappellent Easy Rider.

Esta boutique une lo histórico con un concepto moderno a través de su mobiliario de mediados del siglo pasado, donde encontramos las características lámparas suspendidas de las iglesias o los sillones de cuero de Eames. La lámpara Sputnik, de la era espacial, y la alfombra de piel de vaca, evocan el estilo Easy Rider.

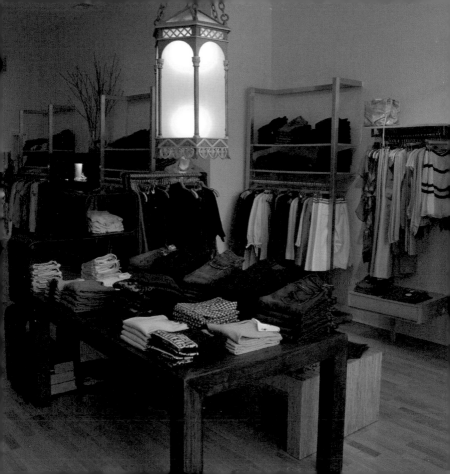

Sprout Home

Tara Heibel

2003
745 North Damen Avenue
Wicker Park

www.sprouthome.com

Emphasizing the belief that home and garden can exist in one spatial environment, owner Tara Heibel stocks the highly contrasting building with contemporary products. While the cement floors and ceiling exude an industrial feel, the walls give the modern garden shop a harmonious look.

Zur Verdeutlichung ihrer Überzeugung, dass Haus und Garten zusammen in einem Raum existieren können, füllt Besitzerin Tara Heibel das kontrastreiche Gebäude mit zeitgenössischen Produkten. Während die Betonböden und -decke ein industrielles Feeling ausstrahlen, geben die Wände dem modernen Gartengeschäft ein harmonisches Aussehen.

Afin de symboliser sa conviction selon laquelle la maison et le jardin peuvent exister ensemble dans une pièce, la propriétaire Tara Heibel remplit ce bâtiment très contrasté de produits contemporains. Alors que les sols et le plafond en béton dégagent un feeling industriel, les murs confèrent une apparence harmonieuse au magasin de jardinage moderne.

Para ilustrar su convicción de que la vivienda y el jardín pueden existir juntos en un mismo espacio, la propietaria Tara Heibel llena este edificio, rico en contrastes, con productos modernos. Mientras que los suelos y el techo de hormigón irradian un carácter industrial, las paredes de esta moderna tienda de jardinería dan al espacio un aspecto armonioso.

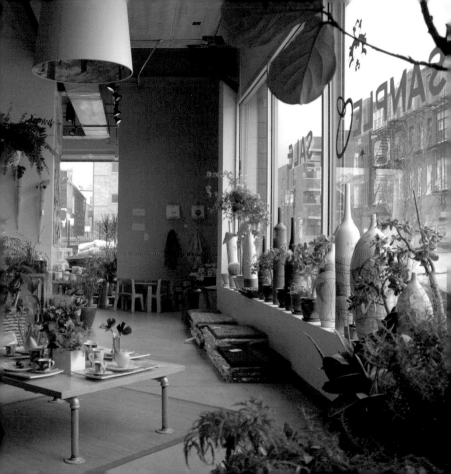

Index Architects / Designers

Index Architects / Designers

Index Structural Engineers

Index Structural Engineers

Index Districts

Index Districts

Photo Credits

Imprint

Copyright © 2005 teNeues Verlag GmbH & Co. KG, Kempen

Published by teNeues Publishing Group

teNeues Book Division
Kaistraße 18
40221 Düsseldorf, Germany
Phone: 0049-(0)211-99 45 97-0
Fax: 0049-(0)211-99 45 97-40
E-mail: books@teneues.de

Press department: arehn@teneues.de
Phone: 0049-(0)2152-916-202

www.teneues.com
ISBN 3-8327-9025-X

teNeues Publishing Company
16 West 22nd Street
New York, N.Y. 10010, USA
Phone: 001-212-627-9090
Fax: 001-212-627-9511

teNeues Publishing UK Ltd.
P.O. Box 402
West Byfleet
KT14 7ZF, UK
Phone: 0044-1932-403 509
Fax: 0044-1932-403 514

teNeues France S.A.R.L.
4, rue de Valence
75005 Paris, France
Phone: 0033-1-55 76 62 05
Fax: 0033-1-55 76 64 19

Bibliographic information published by Die Deutsche Bibliothek
Die Deutsche Bibliothek lists this publication in the Deutsche Nationalbibliografie;
detailed bibliographic data is available in the Internet at http://dnb.ddb.de

Editorial Project: fusion-publishing GmbH Stuttgart . Los Angeles www.fusion-publishing.com
Edited by Michelle Galindo
Co-edited and written by Carissa Kowalski
and Tonia Kim (to . go wellness, beauty & sport and to go . mall, retail, showrooms)
Concept by Martin Nicholas Kunz
Layout: Thomas Hausberg
Imaging & Pre-press: Jan Hausberg
Map: go4media. – Verlagsbüro, Stuttgart

Translation: SAW Communications,
Dr. Sabine A. Werner, Mainz
German: Melanie Koster
French: Céline Verschelde
Spanish: Silvia Gomez de Antonio

Special thanks to Peter Ippolito for his expert advise, Hotel 71, Hard Rock Hotel Chicago, Park Hyatt Chicago,
Sofitel Water Tower and W City Center for their support.

Printed in Italy

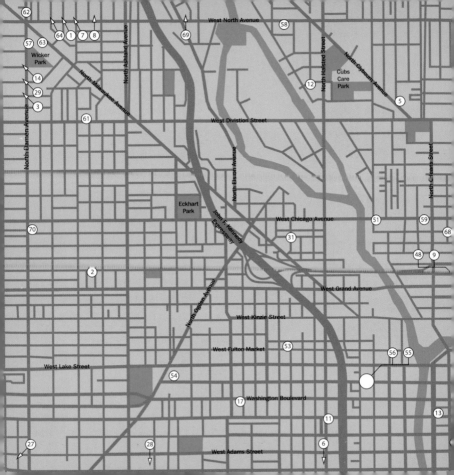

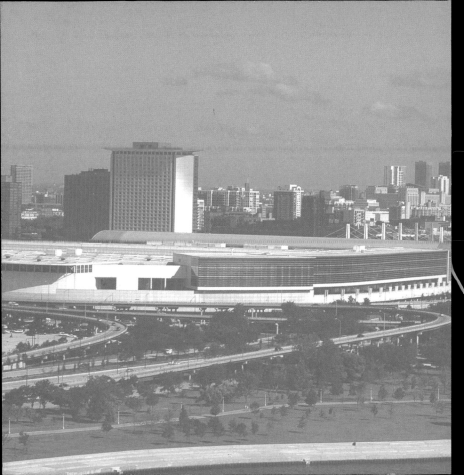